DOMINIQUE GONZALEZ-FOERSTER

THE UNILEVER SERIES

DOMINIQUE GONZALEZ–FOERSTER
TH.2O58

EDITED BY JESSICA MORGAN
TATE PUBLISHING

The Unilever Series:
an annual art commission
sponsored by Unilever

Unilever

Published by order of the Tate
Trustees on the occasion of the
exhibition at Tate Modern, London
13 October 08 — 13 April 09

This exhibition is the ninth commission
in The Unilever Series.

Published 2008 by Tate Publishing,
a division of Tate Enterprises Ltd,
Millbank, London SW1P 4RG
www.tate.org.uk/publishing

A catalogue record for this publication
is available from the British Library

ISBN 978 1 85437 739 5

Distributed in the United States
and Canada by
Harry N. Abrams Inc., New York

Library of Congress Control Number
2008939069

Design: Practise, London
James Goggin and Régis Tosetti
Typeset in
Tate 2058 Regular & Bold

Printed and bound in the
United Kingdom by
Balding and Mansell, Norwich

Cover: Syd Mead
Rainy Expressway (detail) 1968

SPONSOR'S FOREWORD

Patrick Cescau

Group Chief Executive, Unilever plc

Unilever

DOMINIQUE GONZALEZ-FOERSTER'S installation—the ninth commission in The Unilever Series in the Turbine Hall—is one of the most intriguing since we started our sponsorship of Tate Modern in 2000.

Dominique's work—*TH.2058*—takes a look forward fifty years to a London afflicted by an unending rain. Tate Modern is being used as a shelter for people, artworks and the remnants of culture.

The Turbine Hall is filled with replicas of sculptural works by some of the twentieth century's most famous artists: Henry Moore, Alexander Calder, Maurizio Cattelan, Claes Oldenburg and Coosje van Bruggen. It even includes some, like Louise Bourgeois and Bruce Nauman, who have themselves previously undertaken The Unilever Series commission.

TH.2058 continues the tradition of innovation, creativity and experimentation established by previous artists in The Unilever Series, each of whom has tackled this challenge in very different ways. The creative imagination that Dominique has brought to the project is remarkable.

Unilever, as one of the world's largest consumer goods companies, is proud that through our partnership with Tate Modern we have helped to make contemporary art accessible to nearly twenty million people who have come to view the eight previous installations. Hopefully this has brought something new into their lives and stimulated them to think differently.

We hope that you enjoy and are inspired by Dominique Gonzalez-Foerster's work.

DIRECTOR'S FOREWORD

Vicente Todolí
Director, Tate Modern

SINCE TATE MODERN OPENED in May 2000, the vast, cavernous space of the Turbine Hall has provided a stimulating, testing context to the select number of artists who have been invited, through the annual commission in The Unilever Series, to create new work for the space. Over the past eight years the Turbine Hall has been viewed from a set of giant, standing towers; dissected by false ceilings; dwarfed by an enormous tautly stretched PVC sculpture; doubled by a giant mirror and lit by a false sun; packed with stacks of plastic cast boxes; filled by an archive of voices; experienced as a journey through tunnelling metal slides; and cracked from end to end. While each project has developed according to the logic of the individual artistic practice, they have all resulted in new confrontations and challenges to frequent visitors, to those who use the building on a daily basis, or to those who are entering the Turbine Hall for the first time. Following this awesome series of

artistic interventions, the ninth project raises the question of what this space may become in the future, in fifty years' time.

We are delighted to have the opportunity to work with the artist Dominique Gonzalez-Foerster and to provide a space in which her fearless, probing, cultured and highly imaginative vision of the future may take shape. Gonzalez-Foerster is associated with a group of artists who came to prominence in her native France in the 1990s. In past projects she has created environments employing light, colour, sound, film and / or props to immerse the viewer in a particular mood or atmosphere. Though the references and shape of her works vary, a common thread is perhaps provided by her passion for film and literature and the ways in which these media are packaged for the collective imagination.

Jessica Morgan, Curator, Contemporary Art at Tate Modern has worked in close collaboration with Dominique Gonzalez-Foerster to develop and realise her ambitious installation. Jessica's enthusiasm, drive and professionalism have been tireless. Ann Coxon has worked as Assistant Curator on the project with additional support from Katie-Marie Ford and Marcia Ceppo. The installation was managed and overseen by Phil Monk and Stephen Mellor. Stuart Comer has offered invaluable advice for the film and Shuja Rahman has enabled the audio visual component.

Our sincere thanks are due to the artist's gallerist Esther Schipper, and in particular to Barbara-Brigitte Mak at the gallery, who provided constant help on many aspects of the project. Thanks also to the artist's gallerists Tommaso Corvi-Mora, Jan Mot and Atsuko Koyanagi. The installation would

not have been possible without the technical support of a number of individuals and companies. Robert Cicek at Ton + Bild has provided an effective solution in the form of their LED screens: we would also like to thank him for his support in making possible this important part of the project. Martial Galfione has worked carefully with the artist to produce the drawings for the installation. The artist has worked for some time with lighting designer Benoît Lalloz who has been dedicated to this project from the beginning, as well as François Bertrand and Luc Lagier who have provided irreplaceable help for *The Last Film*. Arto Lindsay and Christophe van Huffel have created the excellent sound elements for *TH.2058*. James Enright and Stephen Morahan, in collaboration with the team at Prop Shop (Model Makers), successfully rose to the challenge of constructing large-scale replicas to the artist's specification: without them we would not have been able to proceed. In relation to this aspect of the installation, we would also like to express our deepest gratitude to the following for supporting the project by granting permission to replicate their artworks and providing vital information: Louise Bourgeois; Alexander Rower and the Calder Foundation; Mary Moore, Richard Calvocoressi and The Henry Moore Foundation; Bruce Nauman; and Claes Oldenburg and Coosje van Bruggen. In addition, we would like to thank Maurizio Cattelan for generously agreeing to lend his work, Marian Goodman Gallery for facilitating the loan and Lucio Zotti for his technical expertise.

We have been most fortunate in receiving the contributions of Catherine Dufour, Luc Lagier, Lisette Lagnado, Jeff

Noon, Philippe Parreno and Enrique Vila-Matas for this important book on the artist's exhibition at Tate. Their subtle explorations of the futuristic vision proposed by the artist have provided some rich literature on Tate Modern as well as on Gonzalez-Foerster's work. The authors have not only contributed their texts, but also informed the artist's thinking about *TH.2058*, helping to define the character of the project. The book and leaflet, beautifully designed by James Goggin and Régis Tosetti at Practise, have been made possible by Nicola Bion, Emma Woodiwiss and Roz Young at Tate Publishing, and Simon Bolitho in the Interpretation Department.

We are as ever enormously grateful to Unilever for enabling this series of commissions to take place. Without its open vision and willingness to support the most challenging and ambitious contemporary art, we would not be able to explore the full potential of the Turbine Hall as a site for new encounters, confrontation and change.

Most importantly, we are delighted to have had the opportunity to work with Dominique and to help realise her ambitious plan for *TH.2058*. It has been a fascinating process to observe and we have no doubt that, as with the previous Unilever projects, it will capture the imagination of the public. Our thanks go to the artist for this wonderful experience.

ACKNOWLEDGEMENTS

THE SCULPTURES
Thanks to the following for allowing the reproduction of the enlarged artworks:

Louise Bourgeois *Maman* 1999
Tate. Reproduced with permission from the artist

Alexander Calder *Flamingo* 1973
Federal Plaza, Chicago
Reproduced with permission from the Calder Foundation, New York

Henry Moore *Sheep Piece* 1971–2
Henry Moore Foundation, Hertfordshire
Reproduced with permission from the Henry Moore Foundation

Bruce Nauman *Untitled (Three Large Animals)* 1989 Tate
Reproduced with permission from the artist

Claes Oldenburg and Coosje van Bruggen *Apple Core* 1992
Collection The Israel Museum, Jerusalem. Gift of the Morton and Barbara Mandel Fund, Mandel Associated Foundations, Cleveland, and the artists, to American Friends of the Israel Museum. Reproduced with the permission of the Oldenburg van Bruggen Foundation.
© 2008 Claes Oldenburg and Coosje van Bruggen

Thanks for the loan of the work:

Maurizio Cattelan *Felix* 2001
Oil on polyvinyl resin and fibreglass,
Courtesy the artist and
Marian Goodman Gallery, New York

Thanks to the following for their assistance with the sculptures:
Nick Brown; Alexander Rower, Calder Foundation; Richard Calvocoressi, Henry Moore Foundation; Mary Moore; James Enright and Stephen Morahan of The Prop Shop (Model Makers); Lucio Zotti

THE LAST FILM
Thanks for the following excerpts:

Alphaville, Jean-Luc Godard
Carnival of Souls, Herk Harvey
Le Chant du styrène, Alain Resnais
Electronic Labyrinth THX 1138 4EB, George Lucas
Fahrenheit 451, François Truffaut
Gerry, Gus van Sant
Un homme qui dort, Georges Perec
Invasion of the Body Snatchers, Philip Kaufman
La Jetée, Chris Marker
The Last Wave, Peter Weir
The Man Who Fell to Earth, Nicolas Roeg
Mission to Mars, Brian de Palma
L'Oeil sauvage, Johanna Vaude
Outerspace, Peter Tscherkassky
Planet of the Apes, Franklin J. Schaffner
Région Centrale, Michael Snow
Repulsion, Roman Polanski
Solaris, Andrei Tarkovski

Soylent Green, Richard Fleischer
Spiral Jetty, Robert Smithson
Stalker, Andrei Tarkovski
Teorema, Pier Paolo Pasolini
Toute la mémoire du monde, Alain Resnais
The War Game, Peter Watkins
Zabriskie Point, Michelangelo Antonioni

Thanks to the following for their help:
Katie-Marie Ford; Luc Lagier; Shuja
Rahman; Stuart Comer; Robert Cicek;
François Bertrand; Carole Lepage;
Camera Lucida

THE BOOKS
The Drowned World, J.G. Ballard
2666, Roberto Bolano
Ficciones, Jorge Luis Borges
Fahrenheit 451, Ray Bradbury
Dead Cities, Mike Davis
The Man in the High Castle, Philip K. Dick
Le Goût de l'Immortalité, Catherine Dufour
Hiroshima Mon Amour, Marguerite Duras
Pattern Recognition, William Gibson
Make Room! Make Room!, Harry Harrison
The Lathe of Heaven, Ursula Le Guin
La Jetée, Chris Marker
V for Vendetta,
Alan Moore and David Lloyd
Vurt, Jeff Noon
Un Homme Qui Dort, George Perec
The Purple Cloud, M.P. Shiel
Luftkrieg und Literatur, W.G. Sebald
El Mal de Montano, Enrique Vila-Matas
War of the Worlds, H.G. Wells
We, Evgueny Zamiatin

Thanks to Clair O'Leary

THE PLANS AND DRAWINGS
Martial Galfione

THE LIGHTS
Florent Deville; Benoît Lalloz; Gilles Ravet

THE RAIN
Christophe van Huffel; The Prop Shop

THE MUSIC
Thanks to Arto Lindsay / Kassin
(firma publishing, esponja producoes),
copyright and publishing 2008,
guitar: Pedro Sá, recorded and mixed
by Gabriel Muzak at Monoaural in
Rio de Janeiro

THE PRODUCTION
Dennis Ahearn, Marcia Ceppo, Ann
Coxon, Barbara-Brigitte Mak, Martial
Galfione, Stephen Mellor, Phil Monk;
Esther Schipper

SPECIAL THANKS
François Bertrand, Christophe (it must
be a sign), Nicolas Ghesquière, Jens
Hoffmann, Kaspar König, Luc Lagier,
Lisette Lagnado, Ange Leccia, Pablo
Leon de la Barra, Barbara-Brigitte Mak,
Denise Milfont, Hélio Oiticica, Suzanne
Pagé, Philippe Rahm, Enrique Vila-Matas,
Jean-Luc Vilmouth

JESSICA
MORGAN
INTRO-
DUCTION

LONDON HAS BEEN SUBJECTED to near constant fictional attack over the last century. Destroyed or under siege in novels and films, it has been the victim of fire and invasion, but perhaps most frequently, of flooding. Many such tales of devastation were inspired by the very real London flooding of 1953, which resulted in the construction of the Thames Barrier. While others, some of which precede this event, are influenced not only by documented events but also by the Ur-myth of the biblical flood and the accompanying notion of a cleansing of excess or evil — a dystopia common, it seems, during the Industrial Revolution. In Richard Jeffries's *After London; Or, Wild England* (1885), a Victorian tale of industrially inspired gloom, London is retributively submerged in compensation, it would seem, for the woes of the new commercialism and its accompanying toxic effect. Jeffries writes of this flood: 'Upon the surface of the water there was a greenish-yellow oil, to touch which was death to any creature.' Sidney Fowler Wright's *Deluge* of 1927 is similarly influenced by scepticism in industrial and technological development, and his bleak vision has the whole of England reduced to a few small islands after an unexplained storm. The better-known J.G. Ballard's *The Drowned World* (1962), a prescient tale of solar radiation causing the polar ice caps to melt, depicts a flooded, tropical London of the future, the experience of which leads the inhabitants to regress to a pre-civilisation mentality. Ballard writes of this state, 'Just as psychoanalysis reconstructs the original traumatic situation in order to release the repressed material, so we are now being plunged back into the archaeopsychic past, uncovering the ancient taboos and drives that have been

dormant for epochs... Each one of us is as old as the entire biological kingdom, and our bloodstreams are tributaries of the great sea of its total memory.' Even more recently Kim Stanley Robinson and Stephen Baxter have both envisioned the capital submerged in *Blue Mars* (1997) and *Flood* (2008) as the city continues to come under a watery, literary attack.

For Dominique Gonzalez-Foerster's Turbine Hall project, which goes by the appropriately science-fiction inspired title *TH.2058*, an unspecified rain has been falling constantly on the city, causing the inhabitants to seek shelter in Tate Modern's now-disused Turbine Hall. This never-ending drizzle (reminiscent of the hazy downpours of such cult science-fiction films as *Blade Runner* and *Solaris*) is apparently also the reason for the monstrous growth of some already over-sized public sculptures, which have been brought inside the Turbine Hall to prevent their further mutation. Filled with utilitarian bunk beds scattered with books, the animal forms of the gargantuan sculptures, a massive LED screen playing edited extracts of more or less recognisable scenes from science-fiction and experimental films, and piercing lights that suggest some unseen surveillance, the Turbine Hall has taken on the attributes of an epic film set.

As a genre we are unused to the manifestation of science fiction in art. Literature, film, architecture, graphic art and digital media are the familiar domains for this rich terrain that has somehow never made serious inroads to the realm of contemporary and modern art. Given science fiction's philosophical capacity to reflect on the present day via an often critically negative vision of the future, it seems surprising

that more artists have not ventured into this loaded world. Though the avant-garde's antipathy towards fiction in general may explain this lack of exploration, combined perhaps with a dismissal of a genre so closely associated with the commercial production of the film industry or the bestseller pervasiveness of the 'airport novel'. Despite, or perhaps as a result of its often-negative analysis of our current condition, science fiction is an enormously popular genre and as such perhaps considered something to be viewed with suspicion by an art world striving for the exclusive.

However, *TH.2058* is by no means easily categorised as a piece of science fiction. A variety of other sources exist for Gonzalez-Foerster's thinking for the Turbine Hall, many of which have featured in her work over the last twenty years, and the installation is, on reflection, highly consistent intellectually, if not immediately apparently aesthetically, with her work so far. The notion of the shelter, for instance — though undoubtedly in part inspired by Gonzalez-Foerster's association of London with the iconic wartime imagery of Henry Moore's drawings of animal-like people cocooned in the Underground during the Blitz — is also a preoccupation that can be located in the artist's series *Chambres*. This sequence of environments made by Gonzalez-Foerster recreated in minimal or elliptical form the interiors of fictional or personal interior spaces and more often than not featured the bedroom quarters of a domestic space. For *Chambres Atomiques* 1994 Gonzalez-Foerster specifically referenced shelter imagery in the bunk bed environment of her installation. And though absent of beds, Gonzalez-Foerster has created other related types of space

that similarly house many occupants such as the various cinema spaces she has designed, for example that created for *Expodrome* in 2007, as well as the transformation of an apparently open terrain such as a public park into a choreographed and thus more contained inter-social realm (for example *Park, a Plan for Escape*, Documenta 11 [2002] and *Double Terrain de Jeu* [*Pavillon-Marquise*], 27th São Paulo Bienal [2006]). These environments are similarly about the experience of being in while simultaneously retaining the surrounding spatial experience that is so distinct from an object relationship.

Most characteristic of Gonzalez-Foerster's oeuvre and evident here both in the montage of extracts that constitute *The Last Film* as well as the replicated, over-sized artworks by Louise Bourgeois, Alexander Calder, Maurizio Cattelan, Henry Moore, Bruce Nauman, and Claes Oldenburg and Coosje van Bruggen, is her use of quotation. Other artist's works have appeared in miniature form in *Roman de Münster* 2007 for example, while the pervasive presence of extracts from books, or indeed the books themselves in *TH.2058* as well as her series *Tapis de lecture*, is a common thread that has run through Gonzalez-Foerster's literary-inspired projects. For *TH.2058*, as indeed in all Gonzalez-Foerster's use of quotation, the selected references are by no means unconsidered. While some of the artist's works are included for their indelible association with the past narratives of the Turbine Hall—Bourgeois's massive *Maman* for instance or the Nauman, also from Tate's collection—others have been selected for their association with a form of public sculpture that exceeds the containment

of a singular object — such as Calder's soaring *Flamingo*. The contribution of Oldenburg and van Bruggen summarises their radical introduction of the blow-up, a distortion seminal to much late-twentieth-century art and one here taken up by the trickster contemporary position of Cattelan.

The Last Film, so mesmerisingly described in this book by Luc Lagier, is similarly a carefully selected accumulation of quotes taken from sources such as the experimental films of Chris Marker and Peter Watkins, and the science fiction of George Lucas and Nicolas Roeg. Gonzalez-Foerster has identified relevant scenes of shelter and archives, as depicted for example in Richard Fleischer's *Soylent Green* as well as Alain Resnais's *Toute la mémoire du monde*, that inform the space of *TH.2058* as well as abstract sequences of loaded urban expectation including the endless rain in Peter Weir's *The Last Wave*, the final shots of Michelangelo Antonioni's *Zabriskie Point* and the dystopian vision of a world without books as represented in François Truffaut's adaptation of *Fahrenheit 451*. While the filmic quotations exist in powerful visual presence on a giant LED screen, of equal importance is the physical presence of the books distributed among the beds offering the relatively internalised experience of Gonzalez-Foerster's references. Among the novels to be explored are J.G. Ballard's *The Drowned World* and Ray Bradbury's *Fahrenheit 451* but also Jeff Noon's *Vurt*, Jorge Luis Borges's *Ficciones*, Enrique Vila-Matas's *Montano's Malady* and Catherine Dufour's *Le Goût de l'immortalité*.

August 2008 in London was one of the wettest on record for a century. Fiction is apparently becoming reality. Gonzalez-Foerster has noticed a parallel not only between her projected

forecast in fifty years and the present day — all science fiction as always, even perhaps unwittingly, being a commentary on the current condition — but she has also identified similarities with the period fifty years earlier, around 1958. Many of the films, novels and references artistically and conceptually that infiltrate *TH.2058* derive from this historically significant time. A moment of Cold War unease, the 1950s of America and Europe in particular were marked by occurrences such as the foundation of NASA and the launch of *Explorer I* (the first US satellite), the development of the microchip by Intel, the establishment of the European Commission (the first stages of the EU), and in Latin America the inauguration of the city of Brasília. All are events that in retrospect seem 'ahead of their time' in some respect. In fact, as much as science fiction is presented as a 'glimpse into the future' it is not only a commentary on the present but perhaps more than anything a reflection on the past. While the rain of the past summer may seem unnervingly to have been predicted by Gonzalez-Foerster's vision of the Turbine Hall as a shelter, perhaps there is much more to be discovered by examining the work's proposal in relation to the events of fifty years ago. Are we going forwards or backwards? Is the past in fact our future? How many years does it really take before we can recognise where it is we have been? The archive of cultural production proposed in *TH.2058* offers perhaps just a glimpse of some potential answers.

JEFF NOON
ARTWORK 2058: PROBABILITY CLOUD

O23

01

AUDIO GUIDE *Gallery 27 contains a single artefact known as <Mirror Tomb>. Blank exercise books decorate a large mound of earth, which supports a central slate structure. Silver mist hovers around the work. Visibility is near zero, with a random ten-second burst of intense brightness occurring once a year. The viewer's face may then be seen, reflected in the slate's highly polished surface.*

[Artist: Maria Novus]

JOURNAL ... standing at the doorway, looking into the gallery. The fog drifts around the tomb. Never actually seen the lighted version. Wilson has a theory that the artist herself is actually buried here, in the soil. For years nobody listened. Now exhumation due to start, two days time. I will have to —

Singsong BLEEP of a voice in my earpiece, a message from Eva ... They've found a new exhibit.

... corridor, 3rd level, heading towards mezzanine.

I can feel the building tremble around me. A genie sleeps in the busted computer system, awaiting reactivation. Strands of human hair hang from the vents overhead, each one torn at the roots from the skulls of dead film stars. Cabinets filled with cast-off skins shimmer beneath spotlights.

Mutated insects crawl through the wall cavities, calling to each other in pulses of electromagnetic energy.

... I see Eva standing ahead. Wilson is there also. The whole team, it looks like. What are they staring at?

CATALOGUE OF EXHIBITS <Fallen Angel> depicts a female astronaut, long dead, crinkled spacesuit frozen tight around her. The traveller's face is visible behind the broken visor of the helmet. She hangs from the ceiling by the wires and cables that presumably once supported her inside a landing module. Of the craft itself, there is no sign.

[Artist: unknown]

JOURNAL ... face of the woman. She looks human, or at least partially so. Cold dark eyes behind a web of cracks. Breathing apparatus dangles from her mouthpiece, no doubt torn away in panic.

People talking quietly, nervous. First new piece in ages. Already Wilson is taking notes, reformulating his critical theories.

All I can do is gaze at those dead eyes, abandoned, half human.

They stare back.

... Eva leans in, whispering. She wants to meet.

In secret.

... second floor, over by the <Activated Body Chimes>. The flesh mechanisms stand idle, workings fused by rust.

I make a cigarette from crumbled orchid stamens wrapped in a piece of canvas torn from a painting. The smoke tastes of rotten fruit and turpentine.

A page of manuscript paper drifts in the air nearby.

I let it float along, unread.

Eva arrives. She passes some small objects to me, saying, 'I found these in the woman's hand.'

'Which woman?'

'The astronaut. I had to prise her fingers open.'

There are seven tablets lying on my palm.

Eva moves in close, her lips touching mine. 'I haven't told anybody else.' Breathing: 'Only you.'

Each pill is coloured mint green; each one marked with tiny lettering that spells out the word VISITOR.

Curious.

It's a word I've seen only once before.

What secrets does it hold?

02

THE FLOATING MANUSCRIPT The Quantum War took place beneath the skin of reality. It lasted all of nine minutes. There were no deaths, no wounds. But such deep changes took place in those few minutes, we are only now witnessing their physical and psychological effects.

JOURNAL ... a sparkle of ghost electrons passes through the air. I'm looking down into the central hallway, where Brady is working hard on her latest construction. It's a replica human head, more than fifty times the normal size. Brady calls it <Reconstructed Temple>. She climbs a stepladder, hammer in hand. Materials: discarded audio equipment, cameras, canvas sheets, peeling video screens. Whatever junk she can find.

Brady's trying to reactivate something. But what?

Towards the rear of the great space I spot DeeDee pushing her old shopping trolley up a concrete ramp. Her son's clothes are piled neatly in the metal cage, her only reminder that somebody somewhere used to be alive to her needs. I imagine her voice, muttering away. Some idea that her son still lives, trapped in one of the paintings, caught in an image.

Wilson claims it to be madness.

Perhaps.

Now DeeDee wanders the aisles of the lower galleries. She has become an exhibit herself, set free from the usual frames that hold the rest of us in place.

I almost envy her.

Pieces of A4 paper floating by. I used to read them with passion, searching for clues. Now I barely notice them.

The pills burn in my closed palm.

CATALOGUE OF EXHIBITS <Floating Manuscript> is a work without any set gallery space, rather it may be found drifting in the air throughout the building. The typewritten sheets describe the kind of art that exists after some kind of quantum disturbance, when changes below the molecular level

of reality create random and dispersed imagery. To view such art actually changes the work. Pictures mutate under the watcher's gaze.

[Artist: Soma Katsu]

AUDIO GUIDE *The bookshop is situated on the ground floor, to one side of the main hall. Our extensive range of art books, magazines and postcards will delight any ...*

JOURNAL ... another visit to the language gallery. The letters shine in the dark: electric blue, sunset orange, blood red.

... A ... Q ... X ... C ... W ...

Like neon bugs, they glow for seconds at a time, burning my retina with their heat.

... Z ... K ... E ... T ...

And after the letters have faded, still their blurred images remain at the back of my eye, a brain print.

... O ... G ... Y ...

And then they too fade.

... I ... V ...

Wilson insists the language gallery once held many such letters, arranged into words and held tightly between the pages of countless books. Now the letters roam freely. In a way, the gallery offers hope, that one day the letters might join up once again to make words. And these words might form a sentence. A pathway might then be disclosed, our escape from the building spelled out for us. In all our time here, however, only one such fragment has been witnessed. Wilson has it written down in his notebook. It reads:

… THE VISITOR MAY FIND THE …

I feel ill at ease suddenly, close to falling. And I walk out into the main hall.

The building holds wonders. And yet we know so little. Eva long ago gave up cataloguing the exact number of galleries; the pencilled map would change every time she opened her notepad. I myself have visited only a few of them; but these are the rooms of colour, of sparkle and dust, where glass modules break open releasing their scents and children may one day get lost in the artworks, never to be seen again.

… back to my quarters in the storage units.

How strange my face looks in the mirror. Eyes losing colour, marks on my tongue.

No matter. I swallow one of the Visitor pills with a glass of water … and feel the room sway …

03

THE FLOATING MANUSCRIPT … victims of the Quantum War, their bodies were fully functioning, perfectly attuned to life, but the whites of their eyes were clouded with numbers, and their tongues painted with random letters. Experts are still seeking decryption, even as the world …

ARTWORK 2058: PROBABILITY CLOUD 029

JOURNAL … as I stand in front of the large painting in gallery 9, the one entitled <Columbine Weeps>. The various elements have never truly made sense to me before, but now, suddenly, I feel I am seeing them for the first time: the cold grey eyes of the doctor; his patient, Columbine, with her bowed head and scarred forearms; the mah-jong tiles that lie on the table between them. Now I understand, the game is part of her therapy sessions. She is describing her latest dream, which the artist brings alive in a conjoined image, a man creeping in the semi-darkness like a reptile. He has a seeping face. Upon hearing of this vision, the doctor smiles like a fog-bank aglow with fireflies. His medical instruments are made of pure silver, they glisten in the soft light of the desk lamp.

… the painting gleams.

… my fingers pressing against canvas, melting …

… now I stand within the doctor himself, inside the image. I have skin of pigment, with oil in my veins. And something else; a small glass capsule that I hold in one hand, a fluid inside it. I see it clearly now, the mystery of the object revealed to my mind. Knowledge burns! I am Doctor Levitz of Vienna. 1912. I spend my nights in lowlife bars, staring at the capsule, for it contains my own tears, those wept at the moment of my dear wife's death. I have weighed and analysed the few small droplets myself, to find the exact degree of sadness felt …

… I come round on the floor of the gallery … blood throb in my skull … fingers aching … mouth dry …

Taste of the pill on my tongue.

I manage to stand. The painting looms over me, dark with life. My eyes are drawn to the doctor's painted hand. There it is! The merest glint of the glass capsule hidden in his palm. It was never noticed before, but now …

I am the Visitor.

Now I see.

Now …

THE FLOATING MANUSCRIPT The old idea of Europe disappeared. In the years following the nine-minute war, another kind of borderline appeared, one that travelled the body itself. Art seeped through the now porous membrane where the subject matter merged with the viewer's damaged psyche.

CATALOGUE OF EXHIBITS <Artwork 2058: Probability Cloud> survives only as a web of fragile connections drawn in the reader's mind between four different elements:

1 Spoken passages from an **Audio Guide** to the Gallery. The voice is slightly mechanical, but soothing.
2 Entries from the handwritten **Journal** of Anton Fournier, a visitor.

3 Fragments of text from a work of art known as <Floating Manuscript>.
4 Pages torn from the Gallery's **Catalogue of Exhibits**.

The work as a whole attempts to portray life in the post-reality zone.

[Artist: unknown]

AUDIO GUIDE ... *evidently, a paradox; it should not be possible for the Catalogue of Exhibits to actually contain itself as an item. And yet <Artwork 2058: Probability Cloud> does exist, an object in the world. This would suggest a quantum narrative; the gallery is a folded literary space, where meanings converge at some meta-level of ...*

O5

JOURNAL ... sleep proves elusive. The corridors twist and turn. Sometimes I can walk for minutes on end, only to find myself in a gallery I have just vacated. Wilson has dubbed it Escher-Space, this strange property of the building's inner realms.

... Brady continues with her work on *<Reconstructed Temple>* in the main hall. Eva is helping; she was once the self-appointed curator of this place, now she's becoming an

artist herself. It seems she had bought into Brady's claim of only the creative act itself allowing any kind of legitimate engagement with the gallery as a living entity. The giant head stands perfectly still on a wooden podium, its two eyes closed as yet. On the wall opposite, a large video screen has been set up. Brady's hoping to capture the dreams of the head.

DeeDee circles the hall with her trolley, calling out her lost child's name over and over.

… meanwhile, I keep staring at the Visitor pills. Six of them left. When I think what taking just one of them felt like, the clarity it gave me. The way the painting revealed its secrets …

… digging has started in gallery 27. Soon the <Mirror Tomb> will be opened. I watch them for a while, as the team workers carefully record the position of the blank exercise books before removing them. Now they start to sift the earth away from the mound, working like archaeologists. Wilson is strutting around looking suitably concerned. A plaster cast of a bird's wing has been found, the feathers encrusted with rubies and emeralds. What else will be uncovered? Is Wilson right, in his theory of the artist being buried within her own work? We shall soon see.

I remember: Eva once asked her husband how he would like to live the rest of his life. Wilson replied that he'd like to stay human, if at all possible.

I'm not sure if I know what he means.

I step out into the next gallery along, where I swallow two of the tablets. As I do so, the painting on the wall opposite starts to move towards me …

CATALOGUE OF EXHIBITS Can a subconscious mind be aroused within dead matter? This question lies behind the creation of <Reconstructed Temple>. The speaking module contains tubes where nascent language merges with the air; electric prayers whisper through the valves. Hopes persist that one day the lips will part to speak a poem of the head's own making. The ultimate goal is to activate a dream within the emptiness of the tinplate skull, which will then be projected outwards, into the world.

[Artist: Anna Louise Brady]

JOURNAL ... I walk though darkness. The whole building seems to have shut down around me, although I can sense the insects moving in the pipes within the walls; they are the wandering sentences of the lost narrative of the palace of mutant art. Paper rustles by and I reach out and grab the floating sheet, which glows with a soft blue light. I see my own name written there, one word among many, and all of them slithering on the page, unreadable. The paper drifts away from my hand as I pass along.

Cloaked figures move in the pitch-black space.

They make a painful breathing sound.

I am lost.

A luminous green word settles on a nearby sculpture. Cast adrift from some alien language, the word is speaking to me, or trying to. I cannot translate it.

Another sound: a twig breaking.

Someone or something is closing in.

A spirit?

It moves in pathways of scent as though it were con-
jured from the heart of a flower, a dying flower.

'Who's there?'

There is no answer, no answer to my call. Only my breath
when eventually it returns.

A giant neon moon flares into life high above me.

I recognise it as a work that once hung in gallery 59,
many years ago, and long since dismantled and put into stor-
age. Now it flames again, albeit with a sickened light, a dirty
yellow light.

The female astronaut hangs suspended from the ceiling.

I feel that I am marked to die here, stranded like her, a
traveller from another dimension. I will blur into the paint-
ings and sculptures, becoming the subject.

I can hear Eva's voice in my earpiece, calling to me.

'Anton? Where are you? Answer me.'

Her voice sounds through a veil of noise. I yank the mech-
anism loose.

Silence now.

Silence, where the ghost lives.

Where the ghost moves …

It is a young boy who beckons me closer, to hand me a
sheet of clear plastic marked with an intricate network of fili-
gree lines. He says: 'This is an X-ray of the astronaut's body.
Her veins make a map through the building. It will help you.'

The child's face is daubed with blue paint.

I move on, following the route of blood, which leads me
through into the central hallway.

… I know that shadows stalk the roof space, high up amid the

girders. There is something black and monstrous living up there. My skin crawls as I turn to face Brady's sculpture, the giant semi-human head, which lies on its side now, damaged. It looks like a long-forgotten, half-made god. The crudely painted lips are drooling pigment, the eyes flicker behind their cheap plastic lids. A dream has come alive within the hollow skull and I walk over to the huge video screen on the wall opposite, where a faint image shimmers. Colours move within the screen, slowly taking on shape, forming the soft outlines of closely planted trees. Details tremble into view as I watch: first the tangled branches, then the myriad leaves, the haunted black leaves through which figures glitter and dance. Silhouettes. A warm breeze stirs the forest and now I see the shapes more clearly; a number of pale-skinned mannequins stand half-hidden amid the foliage, five or six of them, their bodies decayed and stained with dirt, overgrown in patches by moss, with missing limbs, with pockmarked faces and smeared make-up. Their mouths smile blankly, their moulded and painted eyes seem to gaze at me through the leaves. Night birds cry and sing in darkness, from the tower of a ruined building in the distance. I am caught there in the spell of art, in the cage of staring. The mannequins move without my noticing; whenever I concentrate on one alone, the others shift towards me. Now the closest stands on the other side of the screen, inches away from me. My hand reaches out, as does that of my partner, my sallow-faced reflection. Our two palms are separated by a thin layer of sorrow. Beetles move in his woven hair, breath stirs from his parted lips. His face takes on a human taint and his eyes yearn for understanding. He is speaking to me. Speaking …

06

THE FLOATING MANUSCRIPT ... at which point the narrative crashes. Stripped of words, books are the silence of their time; plots dissolve into so many random particles. The clouds of probability float outwards from the moment of collapse.

JOURNAL ... Eva and Wilson are talking to me. Eva has such tender concern in her eyes. Wilson is asking me questions I cannot answer. He is tearing out the pages of his notebook one by one. I was found, apparently, wandering the corridors of the fourth floor in a daze. How did I get there from the main hallway, which routes did I travel? The words in my journal are blurred on the page.

DeeDee moves slowly around the lower galleries. Her voice calls out.

... Wilson was right after all. The body of the artist has been uncovered within <Mirror Tomb>. The corpse was partially mummified, the skin covered in hieroglyphs. Eva is trying her best to decipher the code.

There is no need.

Wet and dark with dirt and blood, the flesh ...

AUDIO GUIDE ... *Now the visitor haunts the twisted corridors with a sense of trepidation. Something is going to happen,*

some new artwork come into being. Nobody will listen to him, people avoid him in the corridors.

CATALOGUE OF EXHIBITS ... apparently <Vein Map> was brought back by Fournier when he emerged from the drug-induced vision. He studies the thin plastic of the X-ray sheet daily, noticing that the exit doors are clearly marked, all four of them. Why then is he so hesitant to leave?

JOURNAL ... Gallery 49, the top floor. A new painting has been found. Entitled <*London After the War*>, it depicts a dark forest and a family of lost mannequins. Beyond the trees lie the fog-mapped ruins of a church, where the statue of Our Lady of the Seven Wounds stands amid creeping vines and sullen-headed flowers. One of the mannequins stares directly at me from the canvas. I dream of a breath taken beyond the mouth, the lungs, a pathway of gold that climbs away from my body, towards the cold diamond-star sky where the painted moon hovers.

 ... People look at me strangely; they seem to be studying me from a distance.

 I can hardly remember their names.

 Or even my own.

... The giant head sits in the central hallway. It remains impassive. Only I have seen the truth, that such dreams that unfurl within the skull will become real in the galleries. I am drawn to the plasma screen. There are tiny flashes of light within the greyness.

The shifting patterns taunt me.
I swallow the four remaining tablets all at once.
The lights flicker and buzz.

THE FLOATING MANUSCRIPT ... A stray word lands in the mouth of the visitor. He bites down hard, feeling the juice of it coating his tongue and seeping through, deep into his bloodstream. And now his tongue is covered in letters, his eyes clouded with numbers.

JOURNAL ... I take out a knife and carve through the screen. Blood flows down the surface ...

CATHERINE DUFOUR
TATE MOON

THE MOON, 2058

THE DARKNESS WAS IMMENSE, awe-inspiring and eternal. Standing at the prow of the Tate Moon Gallery, Dominique Gonzalez-Foerster watched the Earth setting over the Sea of Tranquillity.

'Is everything to your satisfaction, madame?'

Dominique turned to Theatin, the exhibition's youthful curator. 'I don't know, young man,' she replied. 'I haven't started my visit yet.'

Theatin's handsome features crumpled. 'You recall, madame, that we open in ten hours?'

'Don't fret so, young man. I'm sure that thanks to you everything is more than ready.'

But Theatin remained crestfallen.

People are so serious until they get to be ninety, thought Dominique. With a sigh, she turned away from the spectacle of the earthlight. Climbing onto the little surfboard waiting on the ground, she set it in motion with her toes and it began to slide off down the spiral ramp of the gallery.

'Visitors will arrive through there, madame,' remarked Theatin, indicating a misty archway some ten metres tall that loomed up in front of them.

Dominique Gonzalez-Foerster plunged into the vapour. Shutting her eyes, she took a deep breath. The air had become moist and the temperature and pressure had suddenly risen, suggestive of a jungle and its fevers. Branches rustled. Dominique relaxed as the physical sensations reminded her of Borneo. Looking over her shoulder, she saw that Theatin, his eyes also closed, was equally appreciative of his steam bath.

'I should have made the whole exhibition like that,' she murmured. 'Just changes in air pressure and density, intimate sounds and scents. What's the point of visuals? I should have done it all like that.'

The surfboards moved on, and they were soon emerging from the mist.

'That section is excellent.' Theatin's tone was one of self-congratulation.

'But it's too dark,' Dominique protested, braking violently.

Theatin narrowly avoided slamming into her. 'Really, madame?' he said.

'Indeed, young man. You need a sort of greyish-green light to thin out this pea soup. Just a shade. An infusion of green tea, say.'

'Yes, madame.'

Theatin muttered a few words into his headset and Dominique restarted her board. The giant spiral of the gallery yawned away to her left. To her right, beyond the thick glass panels, reigned only the vastness of space.

To think that fifty years ago I used to find the Turbine Hall huge, she pondered with a wry smile. Even with nigh on a

hundred years behind her, she was still struggling with both the enormity of the Tate Moon and her own nerves.

'Did you know, Theatin, that at the start of the century, in Paris, I did an interplanetary installation. At the time, you realise, it was complete fiction.'

'Yes, madame.'

'I've told you that already, haven't I, young man?'

'Yes, madame.'

'Actually, I've told you three times. You really *must* stop me rambling on like that. It's unworthy of you and me.'

'Yes, madame.'

'Theatin, if you insist on calling me "madame", I'll have to keep calling you "young man". Do you want that?'

'No mad… No, indeed not.'

'At the beginning of the century,' continued Dominique, 'there were still real, bricks-and-mortar museums. And even real shops—I worked with Balenciaga, in Japan. I was a film-maker and photographer. There was real film then, can you believe it? Photo-film, cine-film; film you could wind round your index finger.' She shook her head. 'They were really primitive, those days. I'm happy to be in the here and now. Far from Earth, far from terra firma, far from all that ancient stuff.'

'But then,' enquired Theatin, 'why not go even further? Why turn down a Tate Mars?'

'Because of the Moon's whiteness, the blue of the Earth, the black of the sky and the limpidity of space. I think I've always been searching for contrasts like those. Something akin to the narrow beam of a spotlight falling on a dark-ened stage. Now, Mars—what sort of installation could

you make for Mars? Fifty years ago I used to ask myself that, Theatin. I don't bother any more. Because of the Martian dust storms. I use vanishing points, and on Mars you can't see your own feet.'

I must admit, she thought, *that before opting for Tate Moon, I didn't realise the lunar sands were so grey and sad and the sky so terribly dark. And the stars, seen from the Moon, so hard and unblinking. On Earth, they glimmer, but here they glisten like bone.*

She glanced at Theatin, who was giving orders into his headset. *Admit it? But to whom? What could this Selenite know about the Milky Way twinkling because of the Earth's atmosphere? Or all the different shades of darkness?*

The surfboard dipped, starting down the long curve of the panoramic dome. Dominique braked and tilted her head back: points of light, set into the enormous transparent cupola, spelled out her name among the constellations. She burst out laughing. 'Is that pretentious enough? Sufficiently megalomaniac? I can hear the critics from here, Theatin!'

Against the black background her name glowed like a chain of supernovae.

My name. Written with stars among the stars. In this universe where written words inexorably vanish. At least I shall have fought against that; as long as I can, I shall fight it.

She was peeping through her fingers. 'Reduce the intensity a bit, Theatin. I don't want my visitors to go away blinded.'

The 'Dominique Gonzalez-Foerster' constellation dimmed slightly against the stellar backdrop. A long, green veil began to flicker across it.

'Aha!' exclaimed Dominique with a smile of delight. 'My aurora borealis!'

She and Theatin remained for a long time, craning their necks, admiring the capricious ripples of the electric fields.

Dominique finally said: 'Well done, Theatin, it's magnificent. What better than the wild, streaming locks of the sun to liven up space? Add a touch more pink, that's all.'

Dominique massaged her neck and set her board in motion again, leaving the panoramic hall for a succession of cloud layers. She gave a start when the first rain began to dampen her face; an icy drizzle with a perfume of heather, then big, warm, monsoon-like drops, and finally the little acidic pricks of an urban shower that awakens strange smells—warm tar, plane trees and dog excrement. Dominique smiled, but Theatin pulled a face.

'I still say that's a very peculiar smell, Mrs Foerster.'

'It's a natural smell, Theatin. And it'll bring back plenty of good memories for old folk like me. Isn't it remarkable how childhood memories are—have been for so long linked to nature? People of my generation find it much easier to recall light filtering through the leaves of trees in their earliest playground than the neon tubes in the store where they bought their first hamburger. Is it the same with you, Theatin?

'No,' he replied, 'I've never seen neon.'

The surfboard, drenched in water droplets, was still on its long, spiralling descent. Gently, it slalomed between two dark silhouettes resembling spectators standing motionless in the rain. So blurred were they that they looked distant, even from close up.

The board halted briefly on a glass balcony. Far beneath, the grey lunar sands rolled away into the distance. From the outer rail of the balcony hung pink and green fluffy towels. In contrast to so much sterile dust below, the freshness of the colours sparkled like a waterfall.

'Theatin, do you know how much trouble I had finding an attractive material as soft as that but able to withstand absolute zero?'

'I can believe it,' answered Theatin in a manner suggesting he was perfectly au fait with practical problems posed by the lunar climate. *Second stupid question*, reflected Dominique, restarting her board.

She said: 'The smell of salt is just right, but the sound of the waves needs to be louder.'

'Pieti Tsiet swears the acoustic conditions in this zone make it impossible to increase the volume,' sighed Theatin.

'OK, if Pieti Tsiet says so, we'll do what Pieti Tsiet says,' Dominique concluded. 'He's the technical wizard.'

'You must know as much about it as he does,' grunted Theatin.

'My work as an artist involves every kind of media, not just one, Theatin. In the year 2000, I felt I had at my disposal a toolkit as big as the planet; today, it's the size of the solar system! Which, basically, means I have to put my faith in a great number of specialists.'

'Here comes the high-density section, Dominique. Remember to keep your mouth closed.'

The boards shot into an opaque tube. A few minutes

later, Dominique and Theatin emerged at the other end, pale and exhausted.

'No good,' Dominique panted. 'Still no good. I wanted—I wanted to bring opposites together, a sort of glutinous heaviness and a dry desert heat, but it feels more like drowning in a lava flow. No good.'

She stopped her board. 'I don't go for sensationalism, Theatin! I'm in it to reveal things: to link a feeling to a sound, a thought to a texture or an impression of speed. I want variations of gravity on a station platform with a background of birdsong, not an experience as … as linear as that. I want to provoke questions, not kill my visitors! This isn't a theme park.'

Her expression was one of fury. 'Get rid of this nonsense.'

'What shall I put in its place?'

'Images, colours …'

Dominique shook her head. Those last words were the title of an old song—*I have more memories than if I were a thousand years old…* And of a work by a classical poet—*I am so old that at every utterance I make, I recall the name of whoever said it before me. The dead speak in my place.*

'Use the historical sequence, Theatin. It'll do just as well there.'

Dominique set off again.

'We're now arriving in the hall on the lower deck,' Theatin announced, as the gallery made a right-angled turn.

Suddenly they found themselves confronted by squadrons of flying books. Flapping their pages for all they were worth and zigzagging madly, thousands of paper volumes thronged the immensity of the hall. Dominique began to

laugh, her face dappled with the shadows of invisible foliage. The atmosphere was saturated with pollens and spores. The transparent shell surrounding the hall was continuous and looked out directly onto the void; yet the ambiance was sunny and rural, alive with the rustling of wings.

'It's perfect, this time!' she exclaimed. 'Perfect.'

She abandoned her board and went to sit at the foot of a tower of dictionaries that were humming chemical formulae. Theatin squatted down beside her.

'I've always been such an urbanite,' she smiled. 'How did I suddenly come over all pastoral? I suppose I'm missing Earth, that's all.'

'You can go back whenever you like,' said Theatin.

'Yes, but I hate the travelling. I was already scared in the parabolic aircraft, and then, that damned space elevator, you can imagine ...'

She made a brief gesture with her hand. A passing book caressed the top of her head with its leather cover.

'I began,' she said dreamily, 'by making small spaces look like something bigger. Then I started to arrange big spaces. Next thing I found myself trying to limit spaces that were too big. Full circle, wouldn't you say? What's your opinion, Theatin?'

Without waiting for a reply, she began to sight along her outstretched arms, tracing the perspective lines of the books filling the hall.

'Vertical, horizontal, angled, high- and low-level, tracking ... You must have had an awful job, technically, to keep everything together with this feeble gravity.'

Theatin nodded.

'The aim,' Dominique pursued, 'is to tame the infinite without drawing its teeth. From here, these books in motion provide a measure of the void outside without spoiling the depth of vision.'

'The written word against the background of the void,' murmured Theatin.

'The written word *on* the void, Theatin. I write words on the formless darkness of space. You have to admit it: space is the largest canvas in the universe! You can organise space. Instead of fighting it—a mere waste of effort.'

'The artist's true mission,' intoned Theatin solemnly.

'How grandiose, Theatin,' Dominique cried. 'Actually, I have the impression I'm placing screens between myself and the infinite to deaden my fear of it—I can hardly see myself proclaiming: "I am the Giver of Meaning, the Great Protector!"'

After a moment's consideration, she added: 'Yet it's true, at one time my problem was avoiding an overload. The plethora of sounds, colours, forms … the mass of information. Today, we're dealing with an *underload*. But that doesn't prevent that joy, the joy of space—the joy I've experienced since 1969, almost a century ago …'

She broke off. Theatin glanced up from his position below and observed, with apparent hesitation: 'That joy can last a lot longer. You only need accept NASA's offer.'

'That's enough of that, Theatin. I don't want anything to do with that offer. I've told the people at Tate, at NASA—and everyone else—twenty times: I don't want cloning, transplants, anti-ageing treatments or anything like that. There's no question of prolonging my existence.'

'But... your ambitions?' demanded an unhappy Theatin.

'Another batch of "monstrous workers" will come after me and "start from the horizons where my strength failed".' *Quoting Rimbaud now*, she said to herself. *Things are not improving.*

'But aren't you afraid of dying?' whispered Theatin.

Dominique Gonzalez-Foerster shrugged her shoulders. 'My bones will go drifting off into the Milky Way. I shall spend eternity roaming the heavens. I shall become a sky-walker ... at least, a female one.' *Now it's Star Wars*, she thought with a silent giggle. *Worse and worse.*

'No,' she resumed, 'it doesn't frighten me. We think of dying as rotting in the ground. But dying in space isn't really dying. What does it amount to? Merely an end to one's experiences. And I must admit a certain curiosity about the last few minutes. It must be an interesting time.'

'And all your creations?' Theatin asked with unexpected cruelty. 'Can you be sure they'll be preserved properly when you're gone?'

Little bastard, thought Dominique. She recalled the Paris Metro station she had redesigned like a film studio; she had been so proud of it, and had had to watch it decay year after year, helpless to intervene. A very bad memory.

'I'm leaving that task to you, Theatin,' she declared finally.

Theatin looked utterly shocked. 'Me? That's too much, really!'

Ah, what cruelty. Cruelty and yet more cruelty, Dominique said to herself, leaving the wretched Theatin to struggle with the honour that had just befallen him.

'I don't know if I can manage it, don't you see?'

'Why, of course you can,' purred Dominique, toying with the spots of shadow and golden light filling her hands. *What can I do about it? The deterioration of a work of art is as inevitable as the void between the stars. In the long run, after everything, only space will remain—unchanging, indestructible and terribly dark.*

Theatin stammered uncontrollably. 'I mean … your installations on Earth, I won't be able … I can't cope with the gravity there … remember, Mrs Foerster, I'm a Selenite!'

'Nobody's perfect,' replied Dominique.

While they were speaking—tiny silhouettes seated at the heart of a sunlit bubble—Tate Moon continued to cruise above the Marsh of Sleep, casting its wake to the whim of the solar winds.

THE END

LUC LAGIER
LONDON, BUNKER 11, GALLERY D. AD 2O58

London,
Bunker 11, Gallery D.
AD 2058

MY DARLING,

How could I fail to write to you while I'm in London? As you well know, I've always been very nostalgic and this latest visit has inevitably brought back a flood of memories. I seem to recall that, the first time, I wasn't all that keen on joining you; I was impatient for your stay in London to finish and to have you back. Today, obviously, everything has changed, even my memories. Of course, it was so long ago. Before you went away, before the catastrophe.

It's now 2058—at least if I believe what people tell me. It's been a while now since I've counted the years. I'm not even sure of my own age any more. I only know that I am one of the oldest survivors. Don't worry, I haven't grown a long, white beard, I've not become a sort of tribal elder; I'm merely worn out, like everyone here, young or old.

All this about exhaustion, catastrophe, survivors … I owe you some explanations. It all happened some thirty years ago—or maybe forty. (That bad memory of mine again.) I only know you'd already been gone some years. Thoroughly lonely and depressed, I became part of the great catastrophe. It was very much like the apocalyptic ending of *Escape from*

LA, the John Carpenter film we liked so much. The Earth was extinguished, our technology vaporised. In a few minutes, the planet was plunged into darkness. And then it rained. It is still raining today; after you the deluge, my love.

It was an acid rain that rotted the body, carrying away so many of us and finally altering the atmosphere. So we moved underground, making our homes there. Since then, we've been living like rats; like the survivors in Chris Marker's *La Jetée*, that other favourite of ours.

We restored some semblance of organisation by harnessing what energy remained and economising all our resources, even our breathing. Like everyone else, I was profoundly shaken by the disaster, but maybe for different reasons. It is actually possible to get used to life in black and white, so to speak, in those claustrophobic galleries. On the other hand, living without books, without music, without films … no. Not me, at any rate. Since you went away, I had made a habit—a sort of survival ploy—of re-reading some of 'our' books and in particular of endlessly re-running movies or clips we enjoyed together. Again and again, I managed to hold back time. For a few moments, you were back at my side.

Since the catastrophe, these small miracles are no longer possible. The few films that were saved fell victim to climatic conditions; the copies burned, the culture, art and memory of past centuries were obliterated in a matter of days. I tried to re-create our films in my mind; I made rough sketches of some of our favourite scenes, but the demand on my remaining strength was too great. Finally I gave up.

Year after year I dragged out my existence—or rather a slow death, my memories beginning to fade ... until last month, my dearest.

It was in London. The discovery of a secure vault preserved from the assaults of time, a miracle untouched by the ravages of the new humidity. In this magical place what treasures were rediscovered: a handful of books, the odd painting and, above all, several hundred reels of film. A sort of small, personal film archive. I pictured the scientists in their protective suits exploring the place for the first time, some lucky ones stumbling on the very things they'd been hearing about for years ... The room was declared safe and open to visitors. The pilgrimage could begin.

As I'm one of the last survivors to know what it was like before the cataclysm—I mean the time when the cinema was our whole life—I was invited to take part in discussions about the finds. What was to be done with these reels of film? These millions of images, now reduced to series of still frames, since there were no longer any projectors and insufficient energy resources to build new ones?

I can still hear myself making my impromptu suggestion. Through cinema, we should show the younger generation what the human race was like, tell them about the old world through individual frames, design lessons in history and film studies combining aesthetic analysis and personal recollections, the very first courses in what was tantamount to a new genre.

As you see, I never really lost my appetite for teaching. For years—our years—I wrote on the cinema, taught about

it, sometimes to the point of exhaustion. A hundred times you saw me catch what was then known as a train, worried and depressed at the idea of speaking about the cinema to what we still called students, and then come back some hours later almost euphoric, enthusing about the importance of teaching, exchanging knowledge … until the next lecture. So I surprised myself by proposing to come full circle and resume this old love-hate relationship. Why not? was the response to my proposal. You can imagine the result: euphoria and depression, excitement and nerves, finally the preparations and the travelling.

I only arrived in London the day before yesterday, at this sanctuary that was on everyone's lips, but which few people had yet had the privilege of visiting. What struck me first was the smallness of the room. It was clear you could only get ten or so people in there, even squashing up. I told myself I would be close to my 'students', which would make discussion easier. As there were restrictions on lighting, we worked out a very basic arrangement: the selected frames would be placed on a miniature light table and studied using a small magnifying glass.

Now for the most important items: the reels of film, miles of it, millions of rescued still frames. Over a hundred years of film history encapsulated in a handful of movies. Whoever chose the titles had been pretty ruthless, but it was all there: the silent era, the Russian avant-garde, neo-realism, musical comedy, the New Wave, New Hollywood, 'cinema gore' … nothing was missing. I then opened the cans (with what care you can imagine), unrolled the films, looked through

them, selected and edited. An extraordinary sensation, losing oneself amid so many ghosts of another age ... All these petrified images rekindled in me a thousand memories and a single face ... yours, of course, which I seemed to recognise in the features of so many actresses ... Some inexplicable resemblance, some trick of the brain ... But I had to get a grip on myself; I had lectures to prepare.

So my 'students' wouldn't be completely lost, I soon realised I would have to explain what the film frames couldn't: embroider a bit, fill in the missing links. I prepared to take on the role of the pianist of the early cinema: an accompanist. A mime artist, an actor replaying scenes. Given my failing memory, I knew I would be forced to take liberties with the films, reinvent plots, scenarios, characters. I could do as I liked. No one was going to check, were they? ... In any case, as you are well aware, I've always had a problem with film plots. Can't understand them or repeat them properly. Not for me intricate mechanisms and subtle twists and turns. I prefer shortcuts, or a more leisurely approach. A scene, a sound, a shot frequently sufficed in the past for me to work out a film, sometimes without even having it on screen.

In the end I chose about twenty frames. Twenty fragments to exhibit and talk about. I particularly sought out obscure connections, covert references, improbable echoes linking images, sets, motifs, expressions. With these reminiscences, I told myself, it might be possible to re-create some sense of motion and restore some life—why not?—to all these dead frames.

Well, I gave my lecture; actually several times over yesterday and today. For the first time in their lives, my 'students' found themselves confronted by images from the cinema. They looked, they listened. What I told them was one version of the history of film: ours.

You guessed, of course, that I'd start with that image of Madeleine in Hitchcock's *Vertigo*. No contest! It was the first film I looked for on the list. When I discovered the reels, I was afraid this frame wouldn't be there, that some mad collector, for goodness knows what reason, had simply made off with it.

For years, decades even, I talked to you about this movie, about Madeleine's bewitching charm and Scottie's physical and psychological problems. I remember that very long ago, half-serious, half-ironic, you teased me about my fascination for this platinum blonde—you, the curly-haired brunette … As if people could fall in love with a fictional character, I riposted … Nonetheless, to become a true cinephile, you need those key images, iconic shots that make you want to believe in ghosts …

I began to tell my students that *Vertigo* had just reached its hundredth anniversary; that I had discovered it at their age, as a teenager, and at that moment everything had started for me. It was obvious they weren't listening. Only after a few moments did it dawn on me what the trouble was. Accustomed to a washed-out, virtually black-and-white

world, they had never seen such brilliant colours. Their almost primitive astonishment sent me back to my childhood. That I can remember perfectly. All my earliest film memories are linked to the wonder of colour: *Snow White, The Ladies' Man, Mon Oncle,* and so many more.

I outlined the plot of *Vertigo,* I invented, swapped things around, omitted things. I told them that the image of Madeleine corresponded to the subjective viewpoint of a Scottie in the early throes of love. I described the hypnotic, surreal, near-fantastic dimension of this apparition: the colour filter, the vertical, elusive profile, the actress's pose, the perfect centring. In short—you know all this by heart—Scottie was falling in love with an image lacking perspective or depth: a 'cinematographic' image, needing to be fleshed out. It made me want to prolong the shot, fantasise about the depth, break through the screen; in a nutshell, as I told them, the nature of my love affair with the cinema.

Next I revealed that halfway through the film, Scottie is unable to save Madeleine, who—apparently—has committed suicide by diving from a bell tower. Inconsolable, he plunges into depression and mental illness. He then tries to remodel another woman as the dead lover: Judy, who is neither exactly the same nor totally different. Mourning, loss, melancholy, morbid possessiveness, the obsessive re-creation of what had been... there again, the complete definition of my relationship with film.

Finally, I added that this image had transcended time through other films ... That vertical, enigmatic profile has

La Jetée CHRIS MARKER, 1962
Vivre sa vie JEAN-LUC GODARD, 1962
Hiroshima mon amour ALAIN RESNAIS, 1959

been re-created many times in cinema history, for instance by Chris Marker in *La Jetée*, by Jean-Luc Godard in *Vivre sa vie* and Alain Resnais in *Hiroshima mon amour*.

I didn't go so far as to tell my students that these 'quotations' were always deliberate. After all, images, like ideas, could sometimes migrate unconsciously from one movie to another. All the same …

I finished with a memory connected with *Hiroshima mon amour* and Emmanuelle Riva. Many years ago, I declared, I staged an interview with the actress in a movie theatre. Afterwards a score of spectators approached her, saying little, but staring at her almost as if hypnotised, and eventually stroking her arm as if she were some kind of religious icon. It was astounding, yet at the same time com-

pletely natural. Cinephiles have always needed icons. Without icons, no magic, no dreams, no nostalgia. At a certain moment in cinema history, they left their mark on film in identical fashion …

Next, these three frames from *Guernica*, the 1950 short by Alain Resnais (I can't recall now if you've seen it). As it happens, I'd never been a great admirer of this

film—not of Paul Éluard's script and even less the incantatory style of María Casarès's narration. But the day before yesterday, as I was beginning to check through the reels, I was struck by its value as an act of witness. Also, my students immediately grasped why I chose to show them these images. This first frame of Guernica in ruins couldn't fail to strike a chord, with its similarities to the landscape of our new world.

I talked to them about the great historical events of the last century: the Second World War, the Holocaust, Hiroshima, Nagasaki ... Humanity once before shattered, reduced to fragments. I remarked that, in the wake of such desolation, no one could make films like they did before. Editing, camera movements, the treatment of cinematographic time, the role of the characters, the soundtrack ... Everything was inevitably called into question, everything needed rethinking, took on fresh meanings.

I observed that *Guernica* was an excellent example of this radical rethinking; that Resnais had made it shortly after the war; that it was one of his first professional efforts,

Guernica ALAIN RESNAIS, 1950

and he had had to face an impossible challenge: how to make films after the Apocalypse? How to start all over again, but differently?

I declared, most likely with exaggerated authority, that these opening shots of *Guernica* contained the seeds of Resnais's future work, and of a great part of what has come to be called modern cinema. *Guernica*, I said, was basically a succession of still, black-and-white images: dead images, in fact, that Resnais managed to resurrect by their brutal juxtapositions, their resonance and his careful editing. If the city of Guernica had been reduced to ashes by German air raids, the film too appears a victim of bomb damage, as if through contamination. A world in ruins, a film in ruins. In this radically new form of cinema, the medium—film and its soundtrack—would never again be safe.

I laid great emphasis on the opening sequences, the painfully protracted and slow appearance of Picasso's figures superimposed upon the ruined city. I explained how Resnais believed in rebirth and resurrection, even after such desolation, even in the case of lifeless images, ghostly silhouettes that were mere shadows of the persons they had been in another life; but that this would be neither pleasant nor simple.

Resnais further developed this theme of painful rebirth in his first feature, *Hiroshima mon amour*. You know how important this film was historically, and of course to us as well.

First I admitted that, since the catastrophe, not a day had passed without me thinking of this movie, and especially of its opening sequence. My students couldn't fathom the background image. They thought of barbed wire, a fissure,

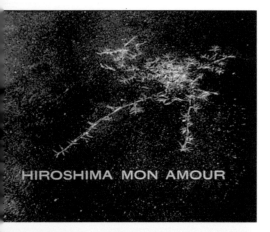

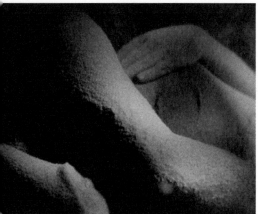

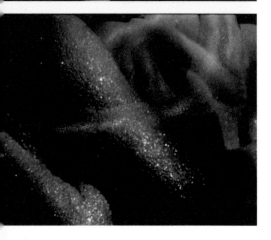

a scar. I was surprised that no one mentioned the words constellation or vegetation, until I remembered they had never seen either of these things. The interest of this image, I started by explaining, lay precisely in the number of possible interpretations; that Resnais had begun his film with an abstract, enigmatic image that demanded decryption, something cinephiles the world over have been attempting ever since.

I made the parallel with *Guernica* since, there too, Resnais chose to open with images of ruins. I stressed that this foreground was actually a negative image in the photographic sense, an image returned from the dead. Then there is that relentless immobility. The image, I pointed out, remains frozen on screen for a long while, perhaps three or four minutes, unchanging, giving the names in the titles all the time to impregnate the film. I described Giovanni Fusco's musical score, tried to whistle it; you can imagine the result ... I showed how the music derives its effect from the constant repetition of the same notes in a sort of endless

Hiroshima mon amour ALAIN RESNAIS, 1959

loop. And how, in a sense, Fusco's score starts almost too soon, with the picture still frozen, as if not yet ready to begin, only half awake. The effect is of the soundtrack waiting impatiently, going round in circles, stamping its feet.

After the titles, the images start to unreel—two bodies emerge in a fade from black to inhabit the film. Limbs and torsos ravaged by the explosion, but also illuminated by a kind of erotic passion, seek out each other in a sequence of dissolves. Shot fades into shot as the bodies embrace. As in *Guernica*, the dissolves underline the idea of rebirth from the ruins, but this time these intertwined bodies develop such energy that the two characters, unlike Picasso's phantoms, produce the effect of real-life movement.

I then related the sequel: the visit to the museum, Marguerite Duras's script, Emmanuelle Riva's confused memories, the café by the river, the cellar in Nevers, the pair wandering through the devastated streets of Hiroshima ... How this nocturnal episode is so painful for them, with its overwhelming sense of loss, its *volte-faces* and hesitations; how it echoes the wanderings of Orpheus in the Underworld, a zone composed, in Cocteau's vision, of human memories and the ruins of their habits.

I added finally that in this reconstructed form of cinema, the self-questioning is extended to the characters. They are made to ponder their actions, their movements in the frame, their words, their memories—and thus acquire a certain autonomy.

To make myself clearer, I took the example we discussed so often: the three images of Hiroshima station. I said

that this scene corresponds to a novel form of escape, where a character takes flight from a fiction in which he or she feels too tightly trapped. The young Frenchwoman is staring at her Japanese lover, as if indicating to the camera what direction to take. She manages to make us look elsewhere, where she isn't, and then takes advantage of this diversion to disappear from sight. I stressed the importance of this frame devoid of the central character. The girl possesses amazing energy, successfully imposing on the traditional craft of the film what it could not tolerate: a vacuum.

I concluded by demonstrating how vital this sequence was and how revealing of that moment in cinema history when the characters were no longer prepared to bear all the world's weight on their shoulders. In need of a simpler alternative, they plotted their own disappearance, simply refusing to cooperate.

I followed this up with Antonioni. I had little choice with all these references to disappearances. I might have chosen images from *L'Avventura* but, as I'm sure you'll recall, we didn't go overboard on this film, preferring in any case

Hiroshima mon amour ALAIN RESNAIS, 1959

L'Eclisse, particularly the final scene. In a way, I was glad they hadn't seen it, as it gave me the chance to describe those almost miraculous backgrounds. I summarised the indecisive affair between Alain Delon and Monica Vitti, the last-chance tryst they arranged one evening, but to which in the end they never came.

Antonioni, himself, does keep his promise, and consequently finds himself quite alone. From then on, what to do next; there is nothing more to shoot, but still film left, and plenty of light and enthusiasm … Antonioni decides not to quit. Oblivious, he continues filming, waiting, hoping. *L'Eclisse* therefore ends with a long, experimental void, virtually unique in a narrative film. Ten minutes without the film's characters on set, ten minutes of abstraction, ten minutes of empty space, unusual shots of plants and trees, buildings under construction, streets being cleaned … The impression is one of an urban desert … and of the ending of a world.

In view of my remarks about the independence of characters and their empowerment or liberation, I naturally mentioned the eponymous heroine's famous stare at the end of

LONDON, BUNKER 11, GALLERY D. 069

L'Eclisse MICHELANGELO ANTONIONI, 1962

Bergman's *Summer with Monika*. In this new form of cinema, the characters had not only gained a certain autonomy, a freedom allowing them to move around as they wished; they were now also able to look where they wanted to. I indicated that until then classical narrative cinema—based on the principle of identification and, by implication, of ignoring the presence of the camera—had eschewed the direct-to-camera shot, judged too destabilising for the audience. Monika fixing us with that lengthy, direct stare was therefore something revolutionary; it astounded viewers, including such luminaries as Jean-Luc Godard and François Truffaut. I described Monika's cigarette, her characteristic touching of her lips, and how, by the sheer power of her gaze, she magnetises the camera, allowing it no choice but to approach, drop its guard and obey. I added that she also manages to modify the space surrounding her. The lights fade, leaving only her face standing out from the darkness. I recalled a montage I'd made a long time back in which I had combined this direct-to-camera shot with a dialogue between Jean-Paul Belmondo and Jean Seberg from *À bout de souffle*: 'I'm staring at you till you give up staring at me …'

Gradually I became aware that all my topics with my 'students' involved desolation, ruin, rifts, evasions or change … Curious, as I had no coherent plan in my choice of frames. Now, however, I appeared to have an obvious fascination with the process of disintegration. A clear penchant for images of emptiness.

After Europe, emptiness and abstraction permeated American cinema. As you know, America fed my adolescent

The Big Shave MARTIN SCORSESE, 1967
Electronic Labyrinth: THX 1138 4EB GEORGE LUCAS, 1967

imagination, as it did for so many teenagers, and some of the directors of so-called New Hollywood became my idols. Out of the thousand things I could have mentioned I had to make a choice. I therefore concentrated on that furtive moment, that decade, in which American film-makers leapt on the bandwagon of their European counterparts and set off on a journey round the modern movement … Once again this took place during a kind of cultural intermission: there was a changing of the guard, a subtle trans-mission of ideas between the faltering pioneers of the old Hollywood and the young lions of the new schools, their heads stuffed with counter-culture.

I started by noting a coincidental date. In 1967, two dir-ectors who went on to dominate the American cinema of the 1970s—Martin Scorsese and George Lucas—were making their first shorts: *The Big Shave* and *Electronic Labyrinth*.

An immaculate bathroom, a desert road, an endless corridor: two sets dedicated to abstraction, two ways of dealing with the void. These unpopulated locations, I began, typified a similar angst to that felt by the writer confronted with the blank page, all three films being youthful efforts by directors still acquiring self-confidence. But I also em-phasised that this cult of the empty space was also positive

evidence of the period of transition. Scorsese and Lucas were at that time hostile to the traditional cinema of the 1960s, which was notable for the very opposite: a tendency to excess. I cited *Cleopatra, My Fair Lady, Doctor Zhivago, The Sound of Music*: multi-million-dollar epics with all their bombast, massive sets and bigger and bigger casts ... The situation was particularly paradoxical. In the wings, the town of Hollywood was bidding farewell to its ageing producers, directors and actors—yet the movies themselves were gorging on this excess and firing their last shots in seeming defiance. A sort of swansong. At the start of the 1970s, the place was beginning to empty. Scorsese, Lucas and a handful of others took over, stepping into the gaps left by hasty departures and revolutionising the landscape of film.

I ended with another coincidence of timing. Ten years later, in 1977, Martin Scorsese and George Lucas were shooting, respectively, *New York, New York* and *Star Wars*. Colossal budgets, special effects, huge sets, casts of thousands. The two had in fact reverted to the Hollywood ethos of the grandiose and the spectacular—the very same they were deriding a decade earlier. From *The Big Shave* to *New York, New York*, from *Electronic Labyrinth* to *Star Wars*, it was New Hollywood's turn to surfeit. Its own swansong came when, once more, excess began to cloy.

Saliva, breath, energy ... I was beginning to run out of everything in that tiny, claustrophobic room. I was about to give up, and my 'students' had doubtless seen and heard enough. I consequently ended with the most important thing,

the thing I felt most strongly about, the new enigma of our time: the rain …

I'm not sure how to describe their astonishment when they saw this image of Clint Eastwood in *The Bridges of Madison County*. They were frightened and wonder-struck at the same time. Can you imagine it, this was the first time they'd seen a man in the rain. A body that was intact, whole: soaking wet rather than burned. Put simply, a living body. For them, this image verged on the miraculous, allowing them to glimpse one of the secrets of the world we'd lost.

This image, I informed them, dated from the 1990s, when cinema and humanity had only a handful of years left to live before the catastrophe. I intimated that it was prophetic; that this fatigue-sodden face must have in some way or another divined the change linked to the rain. The sickening of the weather, then the sickening of the body.

I remember how much we both used to like the rain, especially in the early days. Walking the deserted streets in a torrential downpour, feeling the weight of it on our shoulders, deafened by the drumming of the drops on the ground … I equally recall that when we ceased enjoying the rain, everything went off track, our world, our cinema, our all …

I was exhausted, my darling, but I was absolutely determined to conclude with frames from the last scene in the rain from *Blade Runner*. I've lost count of the number of times we watched this together: ten, maybe. The final scene

LONDON, BUNKER 11, GALLERY D. 073

had always been one of our favourite film moments, one we replayed again and again.

But, my love, the copy of the film that was still kept in this cellar was incomplete. The end was missing. It was surely pre-ordained … my course had to end with a real absence, an unavoidable disappearance. So I had to describe it to them even more precisely.

I started by describing the plot—the Replicants, the Blade Runners, the rain that falls without ceasing, just like now … I described the beauty of Roy Batty, the all-too-intelligent android lost in an impossible existential quest—his blond hair, his wounded face, his body exhausted by the rain. I then finally described the simple way he died, as if he'd taken the decision, with bowed head. They loved this gentle, peaceful death, a million miles from today's agony. I recounted his last words, his confused, failing voice interrupted by hesitations, coughing and gasping. This android, I said, had seen the unbelievable: attack ships on fire off the shoulder of Orion, C-beams glittering in the dark near the Tannhäuser Gate.

My dearest, you must have guessed that I concluded by warning them that those moments would be lost in time … like tears in rain.

I miss you so much.

Luc

PHILIPPE PARRENO
THE INVISIBLE APE BOY

1

THE OWL IN DAYLIGHT

DURING ONE OF THE LAST interviews that Philip K. Dick granted, a few months before his death, he recounted in detail the novel that he was planning to write. The title of this novel, which in the end he never wrote, was *The Owl in Daylight*. He had already been paid for this book and thus had to work overtime; he recalled during the same interview that he had written sixteen novels in five years — *The Owl in Daylight* would have been the seventeenth. K. Dick died of a haemorrhage leaving his words from the interview and numerous research notes. The idea for the novel was inspired partly by an entry in the *Encyclopedia Britannica* in which Beethoven is referred to as the most creative genius of all time, partly by traditional views of what constitutes the human heaven (visions of lights), and partly by the Faust story. But the entire plot really turned around one scientific piece of information K. Dick found about nanotechnology which constituted a breakthrough in information theory, something that had

never happened before: the possibility of storing on a chip one metre square all the information contained in all the computers of the world, and more importantly, all the fantastic possibilities for a fiction to be written.

The Owl in Daylight is about a planet where the atmosphere is different to ours. It is about mute and deaf aliens developing a culture based not on sound but on light. Without sound, they have to use colour for language. Just as humans have audio frequencies, their world strictly employs vision and visual things. Our mystical vision of heaven is the light. Light is always associated with the other world. And the alien world is made of it; its world is made of heaven. So instead of the mystical vision of this civilisation being about a vision of light, it is about the supernatural experience of sounds. K. Dick says: 'what if their world is our heaven and our world their heaven?'

When the members of this other species find the human civilisation, which uses sound and has developed music, they cannot hear it because they are deaf so they build transduction equipment to transform phosphines, or non-retinal images, into sound, and sound into non-retinal images.

They are able to produce some kind of visual score. As we have known for some time, sound does not occur in the atmosphere, it occurs within the body. So the aliens have somehow to create a symbiotic relationship with the human brain so they can use it to conceptualise the music. They can see the music. The assumption is that any civilisation that can build a rocket ship to come to Earth must have knowledge of biochemistry and semiconductors on which biochips operate.

THE INVISIBLE APE BOY 079

When the journalist Gwen Lee stops K. Dick in his flux of words to ask him if this constitutes a real scientific fact, he responds in a panicked instant: 'I am assuming this is not a joke article, I just hope to God this guy's not over there laughing about me writing a book on a non-existent thing. In fact I saw the friend of mine who gave me the article in a store and I said to him "I hope it's not a joke you gave me, I hope there wasn't a thing at the beginning you didn't Xerox which said that this is something unbelievable, that might happen you know in a million years," but my friend said that no that this article was genuine "I guarantee it," he said.'

Why did Philip K. Dick, one of the greatest world-makers of the last century, one of the greatest inventors and imaginers, need to justify his delirious worlds with reported concrete facts? Why did he even need to start from the real? Besides, is this really what's going on there? Is it that the real is called upon to legitimise the imaginary?

Or is the overwhelming heritage of cinema again pervading our thoughts? The definition of cinema as an art form that reflects a gaze. Cinema as a recording tool of a world pre-existing ours. A producer of History.

André Bazin, a French film critic in the 1950s, argued that cinema depicted what it saw as 'objective reality' in documentaries and films of the Italian neo-realist school, but also in the work of directors who knew how to make themselves 'invisible'. He advocated using the deep focus of Orson Welles, the wide shots of Renoir and the 'shot-in-depth'. He preferred what he referred to as 'true continuity' through the *mise-en-scène* to experiments in editing and visual effects.

He was the adversary of a film theory that chooses to emphasise how the cinema can manipulate reality. Bazin believed that the interpretation of a film or scene should be left to the spectator. Here was the idea that theatre was this unique architectural invention of a place built to see something that already happened. It was seen from the point of view of somebody else and was reported in order for you to judge it with your own eyes.

2

THE WORLDS BEHIND THE WARDROBE

Are we confined to ways of describing whatever is described? Does our universe consist of these descriptions rather than of a world or of worlds? Does world-making as we know it always start from worlds already on hand? Is the making always a remaking? World-making always starts with a world already in our hands.

Well I don't know ...

Reality and fiction are like a pair of trees that grow together, interwoven, each sustaining and holding up the other. This suggests a kind of mid-air transfer of strength, contact across a void, like the tangling of cable and steel between two lonely bridge posts. A derived sense of fruitful exchange, or reciprocal sustenance, of welcome offered, of grasp and interrelationship, of a slender span of bilateral attention along which things are given and received, still animating the world in its verbal form.

We use metaphors that help to reveal things that are going on. We live in a moment in time where we should be hysterical, but we aren't, because we are not imagining what is going on. I think we are just getting bits of data. We have the 'CNN Moment,' and in that moment we really feel in the present moment. But then we snap back in an instant into that position that we have always been in.

There are people. There are stories. The people think they shape the stories, but the reverse is often closer to the truth.

We can have words without a world but no world without words, all the stuff that our world is made from is made along with the words. So we are dealing with visions, with depictions rather than descriptions.

3
THE CEPH-ALOPODS

'When I was a kid I always had this fantasy that I could open my mouth and a projector beam would come out; my imagination would be easy and available, or I would have something on my skin like the cephalopod.

The cuttlefish is an animal I am obsessed with and which seems to be so close to the aliens of Philip K. Dick's unwritten novel. It lives not on another planet but in our oceans. These animals can show images and animations on their skin, directly from their imagination. Their brains have a special image-generating lobe, so when they imagine something, it immediately appears on the surface of their bodies. They have evolved to use an animation language to communicate with one another. The reason cephalopods aren't running the planet instead of mammals is because they are born in eggs and just go off on their own. They don't have any childhood and therefore don't have any culture.

We are now looking at an unremarkable rock covered in swaying algae. Suddenly, astonishingly, one-third of the rock and a tangled mass of algae morphs and reveals itself to be what it really is: the waving arms of a bright white octopus. Its cover blown, the creature squirts ink at the camera and shoots off into the distance.

The 'pixels' in the skin of a cephalopod are organs called chromatophores. These can expand and contract quickly, and each is filled with a pigment of a particular colour. When a nerve signal causes a red chromatophore to expand, the 'pixel' turns red. A pattern of nerve firings causes a shifting image, an animation, to appear on the cephalopod's skin. As for shapes, an octopus can quickly arrange its arms to form a wide variety of them, like a fish or a piece of coral, and can even raise welts on its skin to add texture.

As intelligent creatures go, cephalopods are perhaps the most 'other' that we know; think of them as a dress rehearsal for the far-off day when we might encounter intelligent aliens.

In an immersive computer graphics environment or in reading a great story you can 'enter' and then morph yourself into various things. You can have a virtual body, or avatar, and do things like examine your hands or watch yourself in a virtual mirror. Some of the earliest experimental avatars were, in fact, aquatic, including one that allowed a person to inhabit a lobster's body.

Our vocal abilities are part of what enabled our species to develop spoken language. Likewise, our ability to draw pictures—along with the requisite brain structures—was

pre-adaptive for written language. Suppose we had the ability to morph at will: what sort of language might that make possible? Would it be the same old conversation, just a new dictionary mapping the same set of ideas with avatars in place of words, or would it enable us to 'say' fundamentally new things to one another?'

4
THE THIRD DISSOLVING THEORY

Copernicus and Darwin took away our comfortable place in the universe. Copernicus upset the moral order by dissolving the strict distinction between Heaven and Earth; Darwin did the same by blurring the strict distinction between humans and the animal realm. What trait will be taken from us next?

It is all about breaking the limitations of the dialectic and blurring our identity.

Could we take the next step by breaking down the strict distinction between reality and fiction?

This is shocking and sounds like a secular postmodern 'weak' idea. This theory should draw from knowledge like quantum mechanics as opposed to collections of opinions on the level of cultural relativism. Perhaps a radical re-evaluation of the character of time will do it. In everyday experience time flows and we flow with time. In classical physics time is fixed as part of a frozen space / time picture. What if a future scientific understanding of time showed all previous pictures to be wrong and demonstrated that the past, the future and even the present do not exist? We would learn that the idea of woven stories, like our individual personal history and future, are all wrong.

Julian Barbour holds the controversial view that time does not exist as anything other than an illusion, and that a number of problems in physics arise from assuming its reality. He argues that we have no evidence of the past other than our memory of it, and no evidence of the future other than our belief in it. He writes in *The End of Time: The Next Revolution in Physics*: 'Change merely creates an illusion of time, with each individual moment existing in its own right.' He calls these moments 'Nows'. It is all an illusion: there is no motion and no change. He argues that the illusion of time is what we interpret through what he calls 'time capsules', which are 'any fixed pattern that creates or encodes the appearance of motion, change or history'.

5
SOLAR CAPPUC- CINO

In the Pixar/Disney production a young clownfish named Nemo enchanted moviegoers with his epic adventure from the ocean to a fish tank. Before *Finding Nemo* appeared, this species dwelt in relative obscurity compared to sharks and dolphins. The film sparked a booming trade in aquarium fish, endangering the wildlife of the Vanuatu archipelago in the South Pacific. Concerned about the trade, the government set up a committee to examine the issue. Clownfish, which are also called anemone fish, are relatively small. For protection they seek refuge among the tentacles of sea anemones. In a yet-to-be resolved biological mystery, clownfish have mucus on their skin that somehow protects them from the sting of their host anemone. Butterfly fish are predators of the sea anemone. Research has shown that if

the clownfish are removed from the anemone, butterfly fish will move in and devour it. In the movie, one of the tank's residents, a butterfly fish named Gill, tells the newcomer Nemo that 'fish aren't meant to be in a box, kid. It does things to ya'.

There is an aquarium in San Francisco that you absolutely must go and see. Tourists in San Francisco generally visit Alcatraz, so going there is a bit like going to an obscure strip club in Pigalle instead of visiting the Moulin Rouge. The departure for Alcatraz takes place on the same pier. Tourist groups wait for the ferry just a few metres away from the deserted aquarium. The aquarium offers very little of educational or oceanographic interest. It's more of an amusement park than an aquarium although according to Disney standards it's not nearly efficient enough, so that gives it a certain charm. At the end of a quick tour of the aquarium (the glass being so concave that one is obliged to rush through in order to avoid an epileptic seizure) an experience is proposed. It consists of touching a ray or a shark, 'with two fingers only,' explains a girl. You touch the skin of the shark, because the shark is a little silky. When you leave this encounter of the third kind, you happen upon a souvenir shop selling T-shirts that say: I TOUCHED A RAY! Great! So there you have it, it has already been built, the first amusement park of the real.

Michael Crichton is the author of *Jurassic Park*, *Twister* and *Prey*. In 1973 he directed *Westworld*. The amusement park motif seems to be recurrent in all his films, but what is always at the centre of his stories is the fear and anxiety that goes along with such places. We fear that the images of the Jurassic-age dinosaurs, the robots in *Westworld*, the cyclone in

Twister or the nanotech of *Prey* might be real enough to act upon us. One of the great discoveries in *Jurassic Park* was that a sign, no matter how beautiful, when it comes from the pre-history of representation and then enters reality, starts by defecating.

We could imagine building a park of deadly flowers. A tree in India produces beautiful flowers that are lethal; Scotland Yard listed its poison as a product that is totally un-traceable in our organism. They call it the perfect crime tree.

Recently, local government officials in China were criti-cised for spray-painting a barren mountain face green. Laoshou Mountain, near Fumin in Yunnan province, had been left an eyesore by quarrying. But instead of re-foresting the mountainside, forestry officials hired seven workers for forty-five days to spray-paint it green. Some villagers guessed that officials of the surrounding county, Fumin, whose office building faces the mountain, were trying to change the area's feng shui—the ancient Chinese belief of harmonising one's physical environment for maximum health and financial benefit. Others speculated that it was an unusual attempt at 'greening' the area in keeping with calls for more attention to environmental protection. Villagers have been driven from their homes by the strong smell of paint, reported the *City Times*. Local businessman Huang said: 'At first I was glad to see the green mountain, thinking the government was pay-ing more attention to the environment. But then I noticed the great contrast with the surrounding mountains.' Another villager complained: 'We thought the workers were here to spray pesticides before planting saplings.'

THE INVISIBLE APE BOY

According to UK-based British Petroleum's latest marketing campaign, BP no longer stands for British Petroleum but for Beyond Petroleum. The company has installed expensive solar panels on 200 of its 17,000 petrol service stations and launched a barrage of news releases and newspaper, television and billboard advertisements asserting its basic corporate message. A building-sized wall along Washington DC's New York Avenue boldly proclaims: 'Solar, natural gas, hydrogen, wind. And oh yes, oil. It's a start.' Another tries to get beyond the guffaw test with the line: 'We believe in alternative energy. Like solar cappuccino.' The ads on vinyl banners made out of unsaturated hydrocarbon stretch the world's second largest oil company's identity crisis …

6

I'VE BEEN CORRES-PONDING

TH.2058

VIA E-MAIL WITH SOME VERY UNUSUAL PEOPLE, GEORGÉ

I like to imagine fictional characters because it's a way to imagine others. We should call the Other 'Mordor' as in *The Lord of the Rings*. The Other is the one who knows what you know, which is a dialectical problem that is hard to deal with.

The Other is the one who has a nice penthouse on the Death Star.

What about Russian dolls? Baboushkas ... Form within form within form within form. Every nine months a baboushka gives birth to a scaled-down perfect replica of herself!

The smallest child is invisible to the naked eye but very shortly it too will give birth. Some of them have to be seen with the aid of a powerful microscope. Form within form. Where will it end?

Or the astounding clockwork man! Once set in motion this cunning automaton runs for seventy-five years simulating the stages of life.

Or the invisible ape boy.

A superhero that exists only when named.

Recent studies have shown that the Earth's magnetic field is rapidly weakening. In the past 150 years, its magnetic strength has diminished by 10 to 15 per cent. This deterioration could possibly lead to a reversal of the magnetic poles. Over a period of hundreds of thousands of years, its force will wither away to the point of almost complete disappearance. Today the magnetic field shields the Earth from cosmic radiation, and deflects it towards the north and south poles. But as the field dissolves, its structure will change. There will no longer be just two poles, a north and a south, but several different poles all around the Earth. In this case cosmic radiation will not just be focused to the north and the south, but to different places all over the world. Eventually, the field will regain its strength and its original structure, but this time the north will be south and the south will be the north. Already, scientists have tracked how the north magnetic pole is drifting from north Canada towards Siberia. During this long reversal process, the aurora borealis will not just be seen in the low-populated areas of the far north and deep south.

The northern lights will be everywhere.

As a result, all over the world people will no longer look into the night sky to see the stars, but rather will see solar winds directly hitting our atmosphere and setting the darkness ablaze with frenetic neon colours.

At that time, will fiction and reality melt and merge like two historic ice poles?

This question will doubtless be our future.

ENRIQUE VILA-MATAS

TOWARDS A CULTURE OF THE QUOTATION IN A CON-TEXT OF CATASTROPHE

I SUDDENLY ANNOUNCE to Bel, my wife, that I'm going to Dublin on 16 June. I tell her that this day happens to be my parents' 61st wedding anniversary. The two numbers 61 and 16 seem to be related. And naturally I tell her about James Joyce's *Ulysses*, which took place on June 16. As well as the funeral that I'd possibly have to go to in Dublin. A funeral—I don't tell her this at first—that only I would attend. It will be a requiem for the era of the printing press, which reached one of its peaks in *Ulysses*.

'What funeral?' she asks, surprised.

'I'm going to a requiem for the Gutenberg galaxy.'

Bel looks at me as if she wants to bore right through me with her eyes. Silence. Concern. Then she shows me the DVD *Spider*, directed by David Cronenberg, the film we've just rented, and proposes that we watch it after dinner.

As far as I can see, in the film *Spider* the psychological atmosphere establishes subtle links—especially through Peter Suschitzki's photography—with the Antonioni of *Il Deserto rosso*. As in that film, we are once again confronted with evidence that the futility of any attempt rationally to construct the outside world necessarily implies an inability to create one's own identity. Spider tries to know who he is. And in the most memorable sequence he weaves a tangle of strings in his room, like a mental spider's web that seems to reproduce the terrifying workings of his brain. In any case, these clumsy attempts to restructure his personality turn out to be ineffective. He walks in the rain through the inhospitable streets of London's East End, along the old, chilly pathways of his irretrievable

childhood: he has lost all connection with the world, he no longer knows who he is. The anguish he exudes penetrates me as well, leaving me lost, strangely adrift in the dangerous neighbourhood of childhood situated on the borders of my mind, where I could lose myself at any moment. But at the last second I manage to escape from this danger by changing thoughts, by remembering, for example, that the following month I'm going to Dublin, and by remembering that line of Monica Vitti in *Il Deserto rosso*, a line that is almost as dangerous as the danger I wanted to escape from:

'My hair is hurting.'

I too could say the same thing right now. Spider would certainly say it. Spider, who is so lost on his journey through life, does not know that he could imitate me and reconstruct his personality by adapting the memories of other people. He could turn himself into John Vincent Moon, for example, or into a conglomeration of literary quotations. He could become a psychological enclave in the rain, in which various personalities could take shelter and live together and thus manage—perhaps even without too much effort—to configure a strictly individual voice, an ambiguous support for a heteronymous, nomadic profile.

After the closing sequence of *Spider*, I dive towards the computer in desperation. The hours I've spent in abstinence have almost induced a panic attack. As well as pain in my hair.

I sit down in front of the screen, pulling the same face as Spider when he clearly demonstrates his non-communication with a world he does not understand. Foremost among

my e-mails is a message from Dominique Gonzalez-Foerster, in which she tells me about the installation she is preparing after the summer in the imposing Turbine Hall at Tate Modern. Dominique's installations have always fascinated me for the way in which she connects literature and cities, films and hotels, architecture and abysses, mental geographies and authors' quotations. She is a great lover of the art of quotations. As was Godard in his early period, when he inserted quotations, other people's words—whether real or invented—in the midst of his films' action and created—surely without knowing it—an atmosphere of passion for extraneous sentences and for building an apocalyptic culture of the literary quotation, a culture of the end of a journey, or perhaps it would be better to say, the end of a world.

In her installation for the Turbine Hall, Dominique takes visitors to a London in 2058 in which it has been raining unremittingly for years. This great flood has transformed the city, as well as the clothes, imagination and desires of its inhabitants, who now dream about infinitely dry deserts. The incessant rainfall of recent years has given rise to strange effects, to mutations in urban sculptures, which have not only been eroded and invaded by damp but have grown in a monumental manner, as if they were tropical plants or thirsty giants. In order to hold this tropicalisation or organic growth in check, it has been decided to store them in the Turbine Hall, surrounded by hundreds of bunks that shelter—day and night—sleeping men, refugees from the flood. A giant screen shows a strange film, which is more experimental than futuristic and gathers together fragments from Jean-Luc Godard's

Alphaville, François Truffaut's *Fahrenheit 451*, John Huston's *The Dead*, Chris Marker's *La Jetée*, Michelangelo Antonioni's *Il Deserto rosso* ...

On every bunk there is at least one book, a book that has survived the humidity thanks to modern corrective treatments: *The Man in the High Castle* (Philip K. Dick); *Ficciones* (Jorge Luis Borges); *Jacob von Gunten* (Robert Walser); *The Opposite Shore* (Julien Gracq); *2666* (Roberto Bolaño); *High Windows* (Philip Larkin); *Futurology Congress* (Stanislaw Lem); *Urban Voodoo* (Edgardo Cozarinsky); *Ulysses* (James Joyce); *The Divine Husband* (Francisco Goldman); *A Man Asleep* (Georges Perec) ...

Musicians, who combine acoustic string instruments with electric guitars, play some undefined music between the bunks. Maybe they are interpreting the disfigured jazz of the future, or perhaps it is a hybrid style that will come to be known as *Electric Marienbad*. 'The coexistence of the music,' writes Dominique, 'with the rain and the books, with the sculptures and the bunks'—with their replicas of Spider leaning out on all sides—'gives a strange result, as if ghost time had arrived and we were wandering, lost, among the remains of a cultural shipwreck, of an end of the world: an atmosphere of the art of the quotation in a context of cataclysm.'

In her installations, Dominique produces work that seems to be connected to my writing and vice versa. Any rivalry between the two of us is out of the question, as she installs and I write. The atmosphere of a culture of quotations at the end of the world seems to preside over everything. So I now set about imagining some of the extraneous sentences that I would insert, à la Godard, among the bunks and the musicians, or

at the foot of the big mutant statues in the Turbine Hall: sentences that, owing to the impossibility of physically inserting them there, I put in a commonplace book, the workbook which, vaguely inspired by Spider's notebook, I am now launching, at this very moment. I'm starting my workbook with the sentence taken from *Ulysses* ('What's in a name?'), just as I had planned to do. And I continue with some others:

'Quotations have a special interest, as *one is incapable of quoting anything that is not one's own words*, no matter who has written them.' (Wallace Stevens, *Sur Plusieurs Beaux Sujets*)

'Do not wish for anything more than waiting or forgetting.' (Georges Perec, *A Man Asleep*)

'The time had come to head westward. Yes, the newspapers were right: the rain was spreading all over Ireland.' (Vilém Vok, *The Centre*)

'All those moments will be lost in time, like tears in the rain.' (Rita Malú, *Paseo del Nocturama*)

All these quotations could be lost like tears in the rain, but they could also be inserted quite naturally into a novel that I'll perhaps decide to write, that I'm maybe already writing.

We are in 2058 and London's museums have been completely closed for years, due to the infiltration and high humidity and the general catastrophe. The lovers of extraneous sentences and other stray creatures from the big city in the rain come to the depository of tropicalised statues in the Turbine Hall in search of the atmosphere of the culture—now already futuristic—of the art of quotation. And as I observe

the wanderings of the sleepers—replicas of Spider, but also characters who seem to have strayed from Perec's *A Man Asleep*—I remember that I have always wanted to establish a poetry of simulation in my work, maybe as a tribute to the so-called simulators—*versteller* in Yiddish—in Prague's cinemas those men who so fascinated Kafka in the early days of the cinematograph by acting as expert narrators or reciters, who not only added text to the film at whim but also became actors in their own right as part of the spectacle on the screen. They came after the film and added text and sense to what was there already; they multiplied the possibilities of the fable; they imposed the subjective laws of personal interpretation on what was being told; they narrated on top of what was being narrated.

In the face of the futuristic installation that Dominique is preparing, I can no longer restrain my desire to add text and sense, by at least imagining the voice-over for a sequence that can only come to life in the future.

'I am imagining,' says the voice-over, 'that the end of summer has arrived and that I'm going to London to see, in the Turbine Hall, what the city will be like in 2058, the year in which all the people I love will already, like me, be dead. They will be days in which all my dead will already have turned into the moisture of rain and will write from their remote solitudes. They will write in the same way as the rain in Africa: they will write in the same way as Baroness Blixen when her Masai friends asked her to 'talk like the rain', that is, when they asked her to narrate in rhymes that they did not know. They will be 'days of water for sleepwalkers and sleepers,' continues

the voice, 'days for beings drugged by the rain, days for par-
alysed beings subject to the mutation of nature. Days in which
there will be a downpour outside the Turbine Hall, always
in a single tone, and we shall hear the water falling with a
peaceful, uniform intensity, just as when we travel all after-
noon in a train without noticing too much that rain and death
are penetrating deep into our senses.'

A universal flood is falling, just as the rain falls implacably,
without any respite, in the short story *Isabel Watching it Rain
in Macondo* by Gabriel García Márquez, where the water builds
a tapestry in which the damp tangle of Isabel's strange mono-
logue in the heart of the tropics is woven. As with Dominique's
installation, in the tale about Macondo there are also soft, slimy
fungi and repulsive flowers emerging from the humidity. And
there is gloom and there is the spectacle — this time without
any witnesses — of the furniture piled up on the line running
down the middle of the great hall, a spectacle punctuated
by the slow, monotonous and pitiless rain in the street.

'I saw my father,' I remember Isabel saying as she con-
templated the rain in Macondo, 'I saw him sitting in the
rocking chair, his painful vertebrae leaning on a pillow, his
sad eyes lost in the maze of the rain.'

Isabel's monologue was delivered in that brutal space
in which people, in the midst of a hair-raising temperature,
float as if they are on a burning cloud, hounded by loneliness,
decrepitude and madness. I've never read a story in which it
rained so much.

Bel, my wife, is now in front of me. She seems to be ob-
serving my absorption in a mere e-mail with some alarm.

And suddenly I hear her say:

'If you don't mind, let's get back to this requiem in Dublin. A requiem for whom?'

I'm about to reply 'for the Gutenberg galaxy,' when *Ulysses* passes through my mind in a flash, with the funeral that Bloom attends in Dublin on 16 June 1904, and I remember that at eleven in the morning he joins the group that is going to the cemetery to see off Paddy Dignam and crosses the city to the Glasnevin graveyard in a car with Simon Dedalus, Martin Cunningham and John Power, for whom Bloom does not cease to be an outsider. Bloom, for his part, joins the group very reluctantly, because he is not unaware that they mistrust him because they know about his masonry and Judaism, and because ultimately Dignam was a Catholic patriot who boasted about his past and that of Ireland. And, furthermore, he was such a good man that he allowed himself to be killed by alcohol.

'Liquor, what?'

'Many a good man's fault, Mr Dedalus said with a sigh.'

I remember the moment in the sixth chapter of the novel when they stop in front of the funeral chapel. It's a sad chapter, the saddest I've read in my life. The grey burial of a proletarian alcoholic. All the details of the deathly procession are described. And we hope that at some point joy will appear in the shape of a rose, a deep rose, as Borges would say. But this joy takes a long time coming, in fact it never arrives. The process of burying the dead man is also long and complicated. And the grave is as deep as a rose. No, I've never read anything so sad. At the end, the narrator remarks

that they leave some 'rusty wreaths hung on knobs, garlands of bronzefoil' on the coffin. It would have been better to have had flowers, the narrator observes, as they are always more poetic. 'The other gets rather tiresome, never withering. Expresses nothing. Immortelles.' The eternal expresses nothing. Only the deep rose speaks.

Bel persists: 'A requiem for whom?

If I tell her now that I'm going to a requiem for the era of the printing press, for the Gutenberg galaxy, for Spider and for a man asleep, she obviously wouldn't understand and, what is more, it would only complicate things further. She would be bound to stand there looking at me, literally dumbfounded, as if looking at a misfit or a *hikikomori* who has gone completely round the bend. I choose a cryptic reply that will also seem strange to her, although not as strange, I think, as the one about the funeral for the printing press or the one about Perec's man asleep in his bunk in the rain.

'For Paddy Dignam,' I say.

Bel was still looking at me, in astonishment and disbelief. I want to sort things out but I only make them worse.

'For Paddy Dignam, the one with the red nose.'

All I wanted now was for the earth to swallow me up. I shall go to Dublin. And then, after the summer, to London, to see, in the Turbine Hall, what that city will be like in 2058, when all the people I love will already, like me, be dead: when all my dead already form part of the rain and write in the same way as the rain in Africa, write supposedly in the same way as Baroness Blixen, whose Somali and Masai friends sometimes asked her to talk like the rain, that is, in rhymes they didn't

know. Yes. I shall go to Dublin without entirely knowing why I'm going, and then I shall go to London in 2058 to see how the world will be when we are no more. And in the Turbine Hall I also won't know the number of words of my requiem for everybody, of my requiem for the whole of humanity, including Paddy Dignam, and perhaps that will help me say that second and last funeral prayer, a prayer read from somewhere. From the rainbow.

LISETTE LAGNADO

TURBINE-VILLE: SHADOW && FRAYEUR[1]

1 — The title of the present article was drawn from
a combination of three of Gonzalez-Foerster's earlier works.

If only I could forget the notion of art.
Claes Oldenburg

EACH NEW UNDERTAKING by Dominique Gonzalez-Foerster raises a question that is pursued to the limit: where can the artist go when he or she no longer believes in the boundaries of an institution, given that neither the decade of conceptual art nor, subsequently, conceptualism have succeeded in wiping out the more traditional space of access to art? Art has spread through the streets, yards, construction sites, parks, fields, plateaux, rivers, lakes, deserts, forests and mountains; artists have scoured the earth and the sky.

The Turbine Hall of Tate Modern is truly a setting for the excessive—one that challenges the predictability of an attraction and even its decline, and one that favours timeless encounters. Of all Tate Modern's rooms and spaces, features that make it possible to create site-specific and experimental projects distinguish the former machine room. Nevertheless, the Hall has nothing of the marginality of an 'alternative' space; the blockbuster-style budgets it enjoys proclaim that it will do justice to the effects of industrial development on modernity. The post-Adorno cultural critic observes, perhaps

with recalcitrance, the gathering together of professionals and amateurs who descend the ramp in search of wonder and walk on, laden with children, strolling around the floors of the Tate amidst infinite controversies about issues of historical classification. Transcendence in art insists on being celebrated at any cost, even if the authenticity of a piece in the collection happens to be contested.

The sonority of the word 'turbine' reverberates with the sound *urbi* and, immediately afterwards, with *hubris*. Crisscrossed by some five million visitors each year—the number is steadily rising—on the one hand this space competes with national monuments that are the stuff of postcards, while on the other it opens up perspectives that challenge one-dimensional leisure activities and consumption for consumption's sake, true to its mission to convey symbolic content. There are no anonymous, subservient masses here; visitors advance without adhering to the sociology of fascism. The increased speed of their ever-accelerating gaze is not without its harmful outcomes, however, such as the trivialisation of pleasure and the superficial skating over of perceptual and sensory stimuli. In short, the situation—more complex than the present account can convey—does not mask The responsibility inherent in an invitation to move a multitude towards art.[2]

2 — Louise Bourgeois, Juan Muñoz, Anish Kapoor, Olafur Eliasson, Bruce Nauman, Rachel Whiteread, Carsten Höller and Doris Salcedo executed projects in the Turbine Hall prior to *TH.2058.*

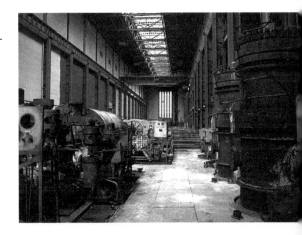

The Turbine Hall,
Bankside Power Station c.1994

The spirit of the energy-generating machines is still present in the atmosphere of the Hall, despite its change of function. Knowing how to move and manage contingents of people on a grand scale derives from a sense of urbanity that extends beyond the goals of a museological institution. In accordance with this line of thought, Turbineville now takes its place in the cartography of *Exotourisme*, the concept upon which Gonzalez-Foerster has been expanding since 2002.[3]

But all dates are subjective and demand revision.

In the 1996 work with Ange Leccia, *Ile de Beauté* (Isle of Beauty), Dominique Gonzalez-Foerster was already beginning to intensify her exploration of itineraries and urban structures, open to collective undertakings, in which leisure and tourism blend with one another.[4] Works based around Ipanema (theories) and Copacabana emerged years before the creation

3 — *Exotourisme*: concept in progress. For an interpretation of this phenomenon in contemporary society, refer to my earlier text: 'Solarium: Exotourism and Creleisure' in *Dominique Gonzalez-Foerster. Nocturama**. This catalogue accompanied the exhibition at the Castilla y León Museum of Contemporary Art (MUSAC), Barcelona 2008.

Exotourisme, DOMINIQUE GONZALEZ-FOERSTER, 2002

of the concept. The neighbourhood of Ipanema, an international metonym for the city of Rio de Janeiro, evokes ' potential participants'.[5] It is worth recalling that a hundred years separate *TH.2058* from the date when the former capital of Brazil conquered the world in its capacity as a musical paradise, thanks to the distinctive beats of the bossa nova, immortalised in so many resoundingly successful tunes; and that Brasília, the new capital from the 1960s, later found its own place on Gonzalez-Foerster's personal map. In search of a capital city in which to film his anthological *Blow-Up*, Michelangelo Antonioni (1912–2007) settled on the Swinging London of 1966.

Ginza Avenue in the heart of Tokyo is another image of permanent transit, of response to social and physical contact. It is possible to pinpoint a certain Ginza momentum that has acted as a motivating force in Gonzalez-Foerster's invitation to other artists to take part in a project at once personal and collective. Although endowed with opposing characteristics (natural versus artificial landscape, minimal use of clothing versus a passion for designer labels), both the Tropics and the Orient have an exceptional capacity for precipitating relationships of exchange and for disorientating the

4 —A number of Gonzalez-Foerster's works share the name *Moment Ginza*, first realised in the Magasin Contemporary Art Centre in Grenoble, and followed by a version in the Färgfabriken in Stockholm and a video in partnership with Ange Leccia and Anne Fremy (1997).
5 —Potential participants is an expression used by Elias Canetti in *Crowds and Power*, 1960. *The Girl from Ipanema*, 1962, by Antonio Carlos Jobim and Vinícius de Moraes, combines celebration and sensuality.

eurhythmics of the old continent. How far away from yourself do you have to go to find contemporary crowds pulsating with the prodigality of expenditure? How far from a city like Grenoble, for example? What distance lies between its own Universal Exhibition, based on hydroelectric energy, and the tourists' powerhouse of Turbineville?

TH.2058

Moment Ginza, DOMINIQUE GONZALEZ-FOERSTER, 1998

Meanwhile, in the Brera Academy, Milan, Gonzalez-Foerster exalted the vertigo induced by a plenary session of authors from all ages (*Bibliothèque* / Library, 1985). Next came her interpretations of numerous rooms or chambers (*Chambres*) sought in the empty spaces between the pillars of a bookcase; *Le Mystère de la chambre jaune* (The Mystery of the Yellow Room) by Gaston Leroux (1868–1927) unfurls in surroundings of green, white, orange, blue, snow white, turquoise, pink (and yellow). Gonzalez-Foerster is drawn to enigmas, much as the book title *La Maladie de la mort* (The Malady of Death) led Maurice Blanchot (1907–2003) to write some of the most beautiful prose about Marguerite Duras (1914–1996) ever set down.[6] The breakdown of a necessary distance and, at the same time, the lack of a common space threaten life itself and confound the 'community of lovers' with the 'community of a prison'. Rooms, especially in hotels ('*dans une rue, dans un train, dans un bar, dans un livre, dans un film, en vous-même*' / 'in a street, in a train, in a bar, in a book, in a film, in yourself'), are reduced to the stuff of contracts, to insomnia, night after night without response. This is perhaps why Gonzalez-Foerster's subsequent *Tapis de lecture* (Reading Rug) of

6 — Maurice Blanchot, *La Communauté inavouable* (*The Unavowable Community*), Paris 1983.

114

Bibliothèque, DOMINIQUE GONZALEZ-FOERSTER, 1985
Chambre de Frayeur Exhibition, DOMINIQUE GONZALEZ-FOERSTER, 1994

2000 was an environment without walls or roof, in contrast to the closure of her sequence of rooms. An innocent invitation to travel, it displays the technological revolution reduced to the interweaving of two types of network—from the printing and typography of the magician Gutenberg to a flying coverlet taken from the bed of *One Thousand and One Nights*. In Gonzalez-Foerster's films *Plages* (Beaches, 2001), *Central* (2001) and *Riyo* (2000), the narrative voice is prompted by a third person expressing themselves in the first person. It rains a lot, that is an adage's adage. The rhythm adopted, drawn from Duras, darkens the tone of dialogues that are themselves far from sunny—'a sudden failure in the logic of the universe' is their diagnosis. In this sense, the extreme luminosity of her later environmental film *Solarium* (with Nicolas Guesquière, 2007) acts like an enzyme released by all the sequences of images impregnated with radioactive chemicals in the hands of the *nouvelle vague* directors and *nouveau roman* authors.

Paradoxically, at first the hours were added up by counting backwards—it is paradoxical because the young artist's custom is to drive with no rear-view mirror. It is an ambivalent necessity: to remember + to reduce to zero → to commemorate, to reduce, to liquidate—an array of verbs that

expresses the context of the pivotal elements in the plane of Gonzalez-Foerster's work. As the years have passed, her auto-narrative has abandoned the literal qualities of the 1995–6 projects and sheer invention, now fully emancipated, has taken possession to such an extent that she called upon Adolfo Bioy Casarès (1914–1999) to act as godfather to the conception of *Park, a Plan for Escape* (Kassel, 2002).

Gonzalez-Foerster synthesises her appetite for fiction, and pays homage to the virtuality of sensation as experienced through reading. Mars is here. In the exhibition *Miniatures — Blow Up* (Robert Prime Gallery, London, 1996), she foreshadowed and @nticipated both her long affair with the Skulptur Projekte in Münster and the untimely British season: the two essential operations are suggested and the die is cast — calculation and premeditation emerge only retroactively. Gonzalez-Foerster upheld more openly the influence

of literary art when she chose the title *Roman de Münster* (Münster Novel) in 2007 for a creation in which the author revealed the works that mark her trajectory, embedding concrete and metal replicas in a green lawn.

In spite of the photogenic images shot in the enchanted playground of the sculpture park, it is only possible to grasp the perversity of this scenario when actually in its presence. Unless you travelled to this small West German city, it was impossible to experience the radical impact of a 75 per cent reduction—replication on a scale of 1:4. Imagine the miniaturised version of Ilya

Roman de Münster, DOMINIQUE GONZALEZ-FOERSTER, 2007

Kabakov's *Looking Up, Reading the Words* (1997). The beauty of Kabakov's original work has a majestic quality which invites us to look up, in search of a starry sky. When confronted with it, we become infinitely small. Suspended words at the top of the sculpture hover like constellations that shine without asking to be interpreted. Gonzalez-Foerster brings the sky into our view, close enough to read and to decipher the beams of a broadcast signal. Her 'Münsterised' version of Kabakov shortens the distance between us and the transcendent; from close by, everything seems more ordinary. She works against the fundamentalism inherent in every monument: the erect posture, head held high. To enjoy a novel, a tale, a romance, you simply have to lie down. And you must also lay down your arms, as Elias Canetti (1905–1994) might have added; [7] to strip the monsters of history of their aura. Not even an abundant bibliography of anomalies, or of frauds, could forestall the taming of the monsters. The unease of an excess of quotations foreshadows a fiction that extends beyond the bounds of conventional physics.

And then comes *TH.2058*, essentially created to be a thriller in three, four, five, *xx* dimensions and enlivened, inside a sort

7— Elias Canetti, 'Aspects of Power' in *Crowds and Power*, 1960.

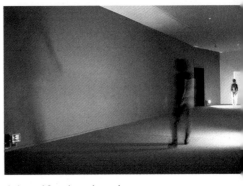

of den, with 'real' animals: a spider — *Maman* by Louise Bourgeois (1999); a flamingo—*Flamingo* by Alexander Calder (1974); sheep—*Sheep Piece* by Henry Moore (1971–2); a cat (is it a cat?) — *Felix* by Maurizio Cattelan (2001); three unidentified animals —*Untitled (Three Large Animals)* by Bruce Nauman (1989); and the remains of an apple—*Apple Core* by Claes Oldenburg and Coosje van Bruggen (1992). Why magnify a spider that is already gigantic? And will changing it from a height of 9 metres to 12 even be noticeable? Doesn't myth already teach us that the heavens will bring down anything that goes 'too far'? Placed on the prospective bench, the ark of the biblical flood wouldn't give Nauman's animals much of a moral chance —nor would it extend one to Dolly the sheep (1993–2003). If it weren't for Noah, there would be no trace now of the multiple documents that clog up the legal system with a chaotic welter of tracks mixing true and false, original, simulacrum, copy, duplicate, multiple, replica and stem cell.

The same monstrous execution of copies is repeated now in London, the international capital of the literature of *shadow && frayeur*—this time introducing the reasoning of the magnifying glass. This 25 per cent magnification, although less extreme than the Münster effect, is following a terminal route: on the horizons of art, the Turbine Hall, that great lair of metamorphoses, struggles to contain works that never stop growing when exhibited in the open air. After shrinking sculptures to the point at which George Brecht's *Void* (1987) —already a metaphysical fraud—almost disappeared from

Séance de Shadow II (bleu), DOMINIQUE GONZALEZ-FOERSTER, 1998

sight, Gonzalez-Foerster this time alludes to the superiority of the forces of the stars over the Museum of Man. It is a clash of the Titans.

Exo, in *TH.2058*, refers less to a country or a planet than to a space outside of nature, foreign time, exteriority, timelessness. We know that the question of the institutionalisation of memory pays tribute to a whole Freudian lexicon explicated in the concept of loss. Could the experience of memory be an effective struggle against the death drive? The technique most evoked is that of repetition: '*l'archive a lieu au lieu de défaillance originaire et structurelle de ladite mémoire*' ('the archive occurs in place of the innate and structural failure of the said memory') — Jacques Derrida (1930–2004).[8]

We arrive at what there is in common between *la maladie de la mort* (the malady of death) and *mal d'archive* (archive fever): la maladie historique (the sickness of history), remarks Nietzsche (1844–1900). Time ahead and time on the wrong side of the road. When seeking to understand

8 — Jacques Derrida, *Mal d'archive* (*Archive Fever*), 1995.

the 'advantages and disadvantages of history for life', the philosopher concluded that 'all action demands oblivion'.[9] I think there is both interest and advantage in retaining this line, even though it may not be made of the most conductive material, for the purposes of reconsidering the work of any and all artists examining the degree to which they absorb and are saturated by the history contained in museums and libraries. Man, as distinct from the animals, needs first to remember if the goal is to forget.

Given the surreal atmosphere created by the juxtaposition of works in different styles (geometrical abstraction has vanished away), Gonzalez-Foerster once more attracts attention because of her adopted criteria of artistic selection. Stolen from its bucolic habitat, a work by Henry Moore (1898–1986) opens the age of dedication to volumes and curves, the natural concavity of shelter. Then the green of the park in *Sheep Piece* is obliterated by the Calder red of *Flamingo*, heading the procession of memory, whose luminosity contrasts with the elegance of its linear shadow. Calder (1878–1976) supposedly removed this work from its strategic location

9 —Friedrich Nietzsche, 'Second Untimely Meditation' in *On the Advantages and Disadvantages of History for Life*, 1874.

beside three Mies van der Rohe buildings in Chicago and it is recovering from another scientific intervention (involving materials engineering) to arrest the serious corrosion that has been attacking it since 1998. The environmental goals of 'Recoating Calder's flamingo' merited a GSA (General Services Administration) case-file:

> *This project included a lead abatement of the origin-al basic lead (red lead) primer by a licensed sub-contractor and the safe disposal of twelve 55 gallon drums of lead contaminated waste by a licensed waste handler in full compliance with State of Illinois EPA requirements.*
>
> *For public safety and due to the limitations of cost-effective containment, the accumulated coat-ings and primer were removed by chemical means rather than blasting...*
>
> *Complete removal of the original coating and accumulated repaintings was necessary because of the high accumulated thickness—beyond 30 mil (30/1000 in.).*[10]

Creatures to be rescued from an apocalypse are migrating to Tate Modern in the hope that a 'civilising' collection will be preserved and displayed—hence the obstinacy in retaining a work even when its scale is distorted. The worst aspect of the Gonzalez-Foerster 'machine' is that since the proportions

[10] —See www.sculptureconservation.com / flamingo

of each piece are respected we find ourselves coming within the range of created monstrosities, with no imbalance or irregularity to denounce. After Hiroshima, the significance of the photographer's intervention in *Blow-Up* has to be reinvented. What does an event say of what was or of what it was? A great deal, Gonzalez-Foerster assures us, as if the very tenor of humanity were dying out.

Due to the fact that it forms part of the tourist circuit, laymen whose activities take them within the sphere of museum organisation are subjected to certain efforts to activate a ruined universal memory. One of the sculptures can be seen here at its original size (and is, in fact, the real thing) while another is present *in absentia*. Although this latter piece was never built, many glimpsed it in the Whitechapel Gallery in 1969 by means of the plates of colour suspended from the ceiling. Gonzalez-Foerster's beds question the fate of the Eden plan, the reclining position of the individual in a group. In her work at Guérigny (*Revenants—portrait de groupe*/Ghosts —Group Portrait, 1990) she had led the spectators to look at themselves in the coloured surface. They are all here among us, those who have already been and those who are still to come. Lying down beside the victims as a form of camouflage is a well-known survival strategy on the part of the wounded. In his

concern for authenticity, Cattelan at least sought to ensure that the skeleton of his feline was credible—felicity for those able to appreciate this *Felix*, loaned to the umbrella of *TH.2058*, the only survivor to converse with its peers from monumental history, thus guaranteeing that it may eventually be saved for posterity. With cells from *Exotourisme* scattered to all points of the compass, *Felix* updates the section accorded to the 'realm of the rising sun' (a translation from the Japanese, *ji-pen-koe*) on a planet that has known a lack of sunlight even as it continues to orbit around it.

For an engaged artist whose sensibility connects to the world, a museum only acquires relevance as a space capsule of onthological and nomadic value; each room, gallery and compartment has the capacity to sail. The preservation and safeguarding of a heritage are not missions that have ever been very apparent in Gonzalez-Foerster's inventories. In fact, rather than appropriating the qualities of the *other*, in her case the action of accumulating references absorbs within it both ceremony and reverence. 'Supplying' and 'stocking' are more fitting terms that help us understand the relationship between the artist and the pilgrims: the filling of a certain lack, and the feeding of a certain hunger, both boundless.

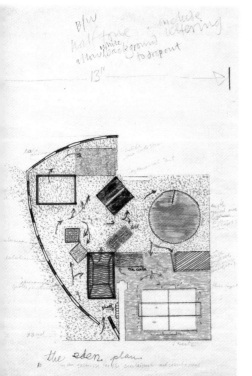

TH.2058

Revenants – portrait de groupe,
DOMINIQUE GONZALEZ-FOERSTER, 1990

At the same time, commissions for artistic projects of this nature are gradually demolishing discursive practice. Writing distorts the artist's intention to live outside the imperative of the model. With its own rhythm, it wins independence from the object, transforming it into a permanent alibi, into an outline of letters crawling on their own bellies and building invisible muscles. In the best of hypotheses, it affirms that which is *to come* and forges ahead. This is awkward too, but, to paraphrase an old saying, to demand is necessary, just as to love is never concise.

This handicap, in which thought seems almost to drag a prehistoric animal behind it so that it might attain the speed of the *other*, separates two destinies. '*Ce sont les deux heures d'un même monde, les deux moments du même monde, minuit et midi, l'heure où l'on jette les dés, l'heure où retombent les dés*' ('These are the two hours of but a single world, the two moments of the self-same world, midnight and midday, the hour when

Felix, MAURIZIO CATTELAN, 2001

the die is cast, the hour when the die falls').[11] A microsecond, and unfitness smashes the result into smithereens, the point into point of view, the exact angle into sentences composing a twisted reasoning divorced from objective description. The task of the review, commentary or critique is bathed in this oppressive substance that divides repentance from redemption.

During a ventriloquist act, in an effort to pay attention the dummy hears a voice that is more or less vague, more or less directed; all its purpose is concentrated on forestalling the speaker's flow. The future cannot be rehearsed. Birth is absolute. The question is: given the future conditions for the production of art, will it be possible to wager on or to antici-pate the sum of the dice in a single go and in partnership with the player? *'Savoir affirmer le hasard est savoir jouer'* ('to know how to assert chance is to know how to play')[12] —the wisdom of Zarathustra welcomes chance as a friend outlines the text that accompanies each play Gonzalez-Foerster makes.

11—Gilles Deleuze, *Nietzsche et la philosophie (Nietzsche and Philosophy)*, Paris 1962.
12—Deleuze (op. cit.) points out similarities between Nietzsche and Mallarmé. *'Les dés qu'on lance une fois sont l'affirmation du hasard, la combinaison qu'ils forment en tombant est l'affirmation de la nécessité. La nécessité s'affirme du hasard, au sens exact où l'être s'affirme du devenir et l'un du multiple … Nietzsche fait du hasard une affirmation.'* ('The dice that you throw once are the affirmation of chance, the combination they make as they fall is the affirmation of necessity / Necessity estab-lishes itself from chance, in the exact sense that being establishes itself from becom-ing and one from the many … *Nietzsche makes an affirmation out of chance.'*)

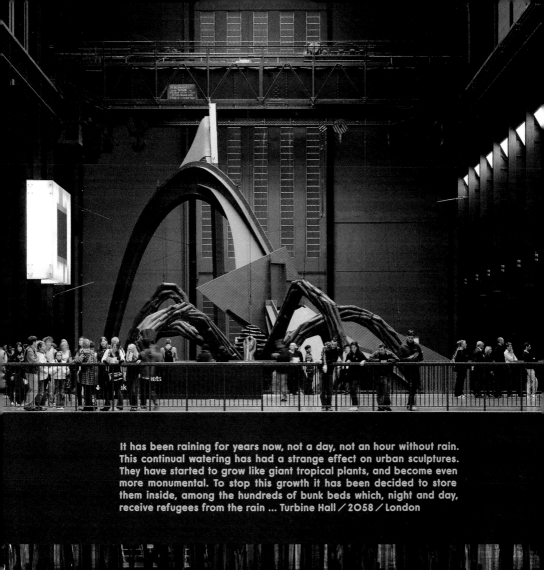

It has been raining for years now, not a day, not an hour without rain. This continual watering has had a strange effect on urban sculptures. They have started to grow like giant tropical plants, and become even more monumental. To stop this growth it has been decided to store them inside, among the hundreds of bunk beds which, night and day, receive refugees from the rain ... Turbine Hall / 2058 / London

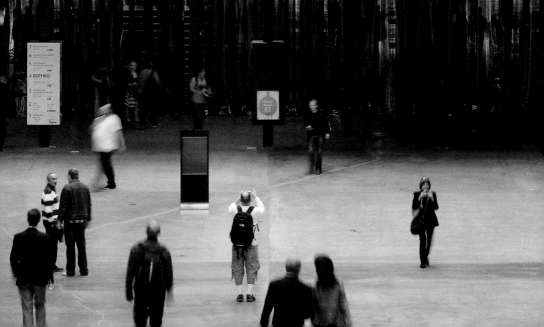

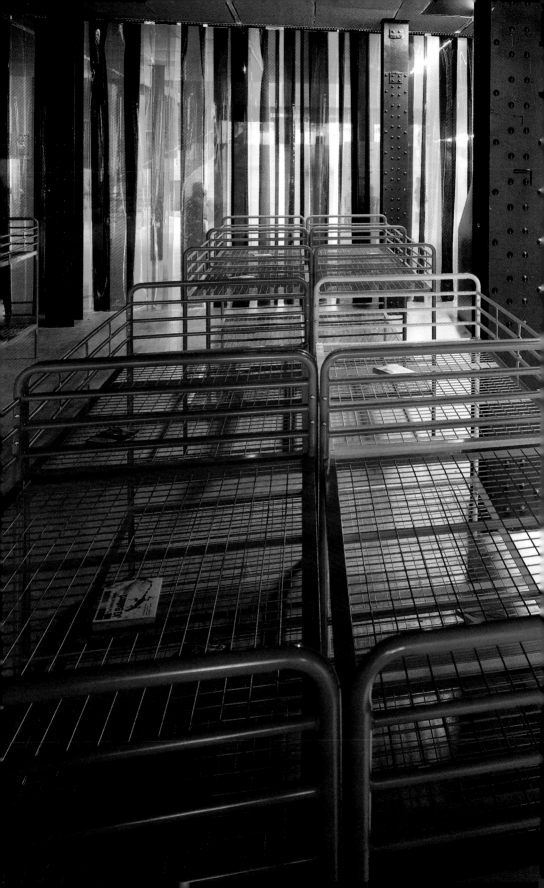

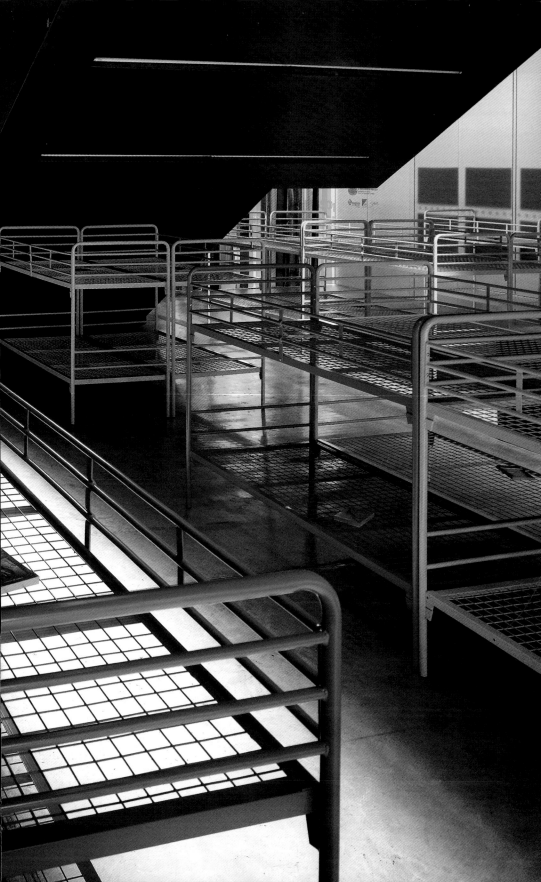

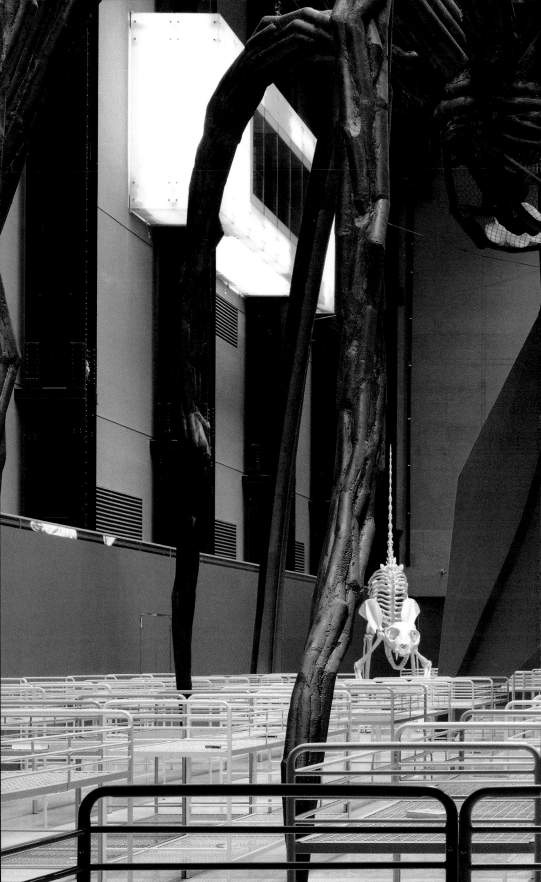

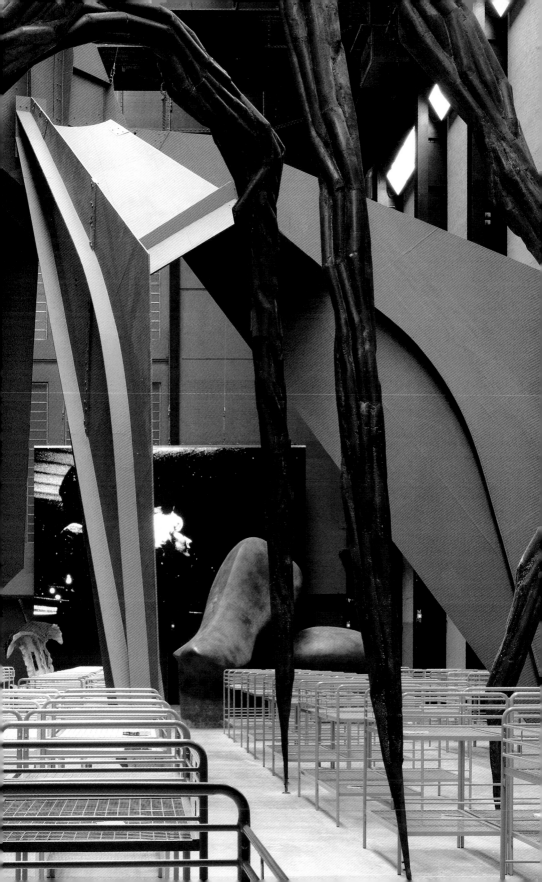

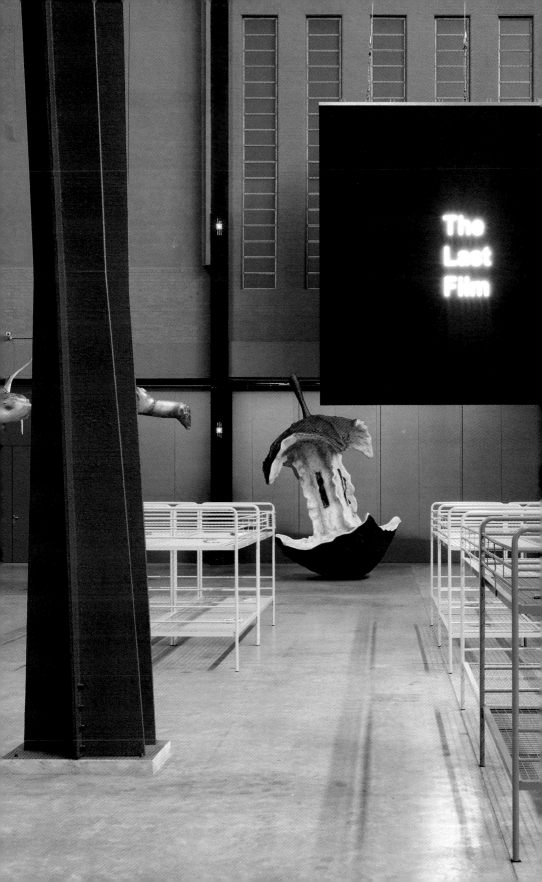

TH.2058 135

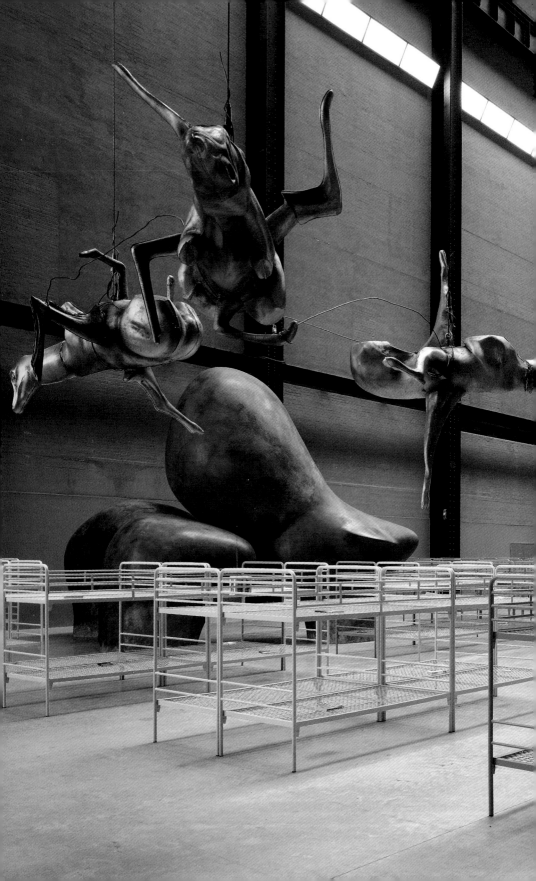

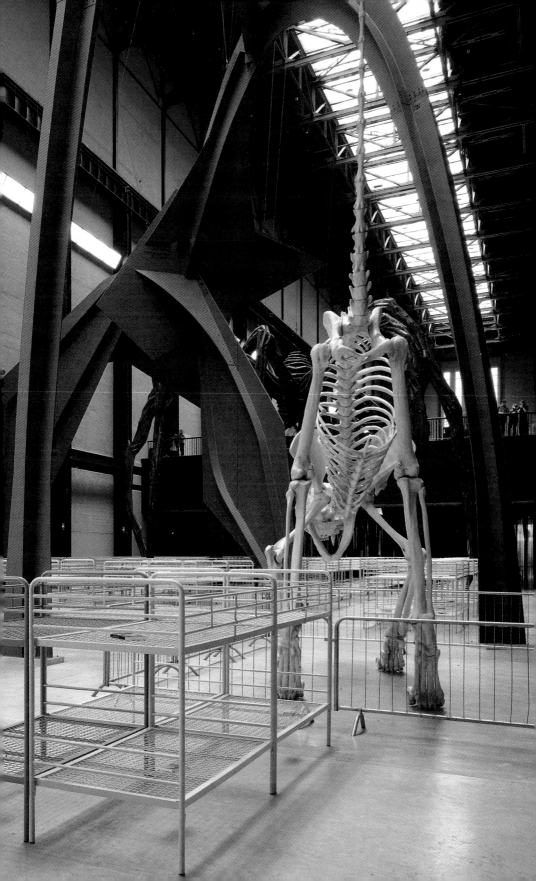

TH.2O58

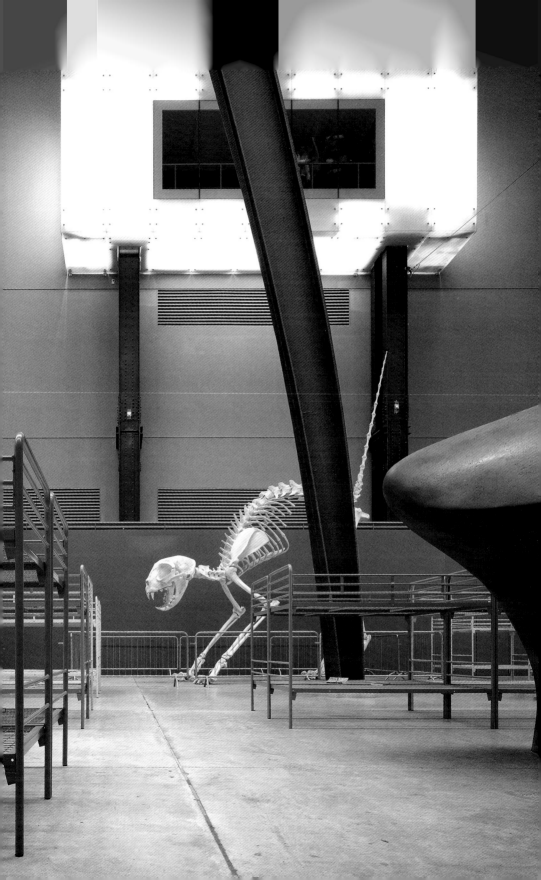

TH.2058

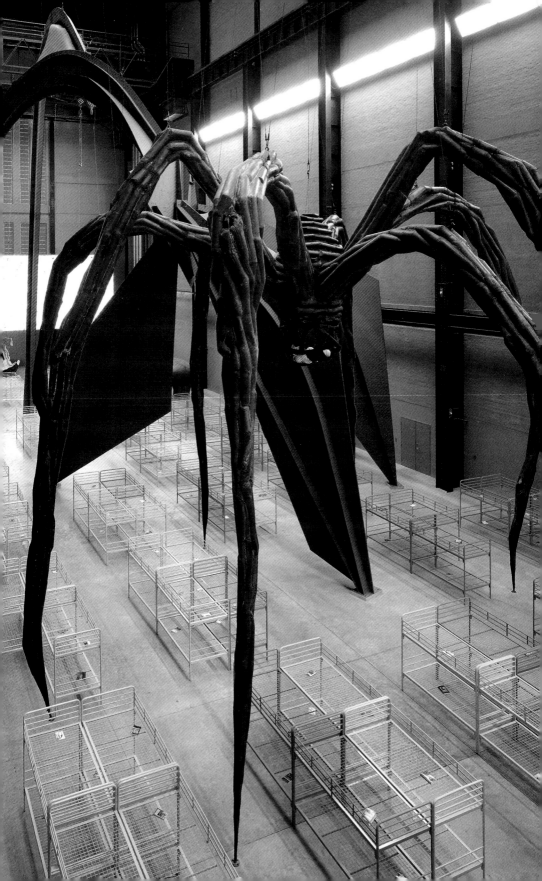

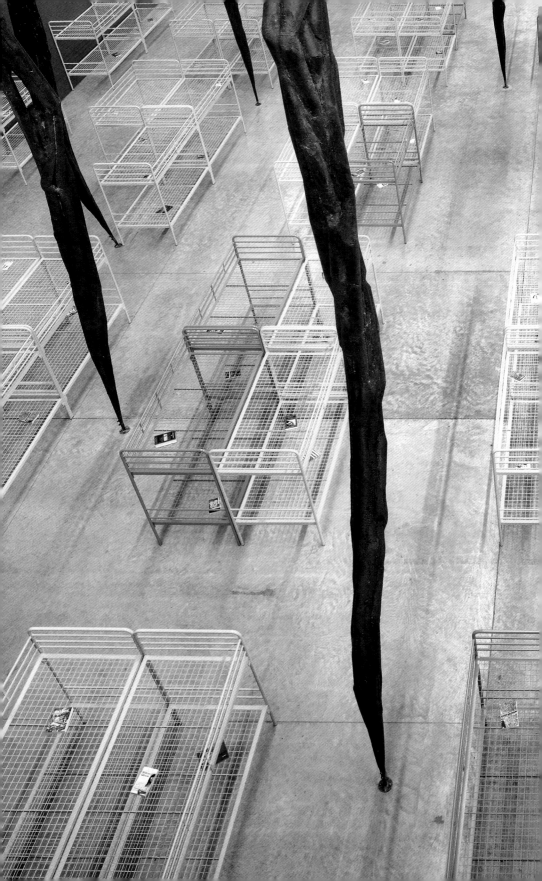

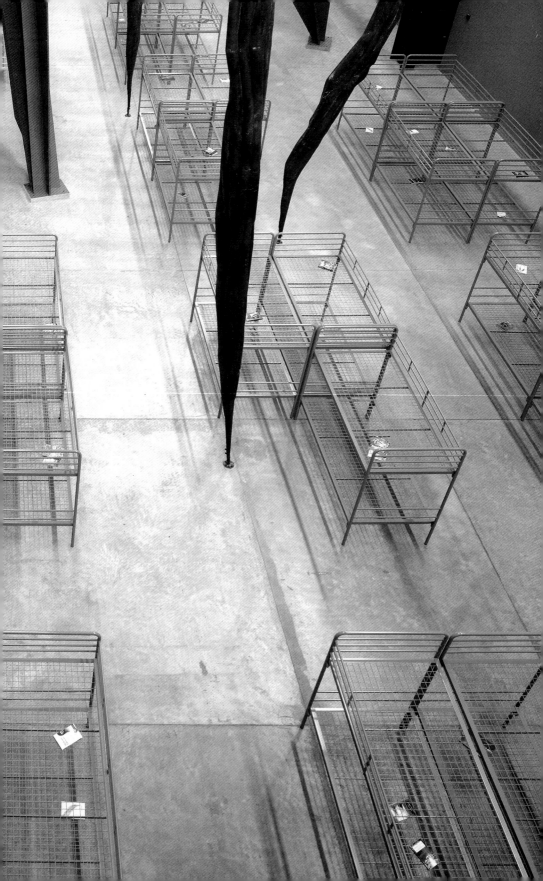

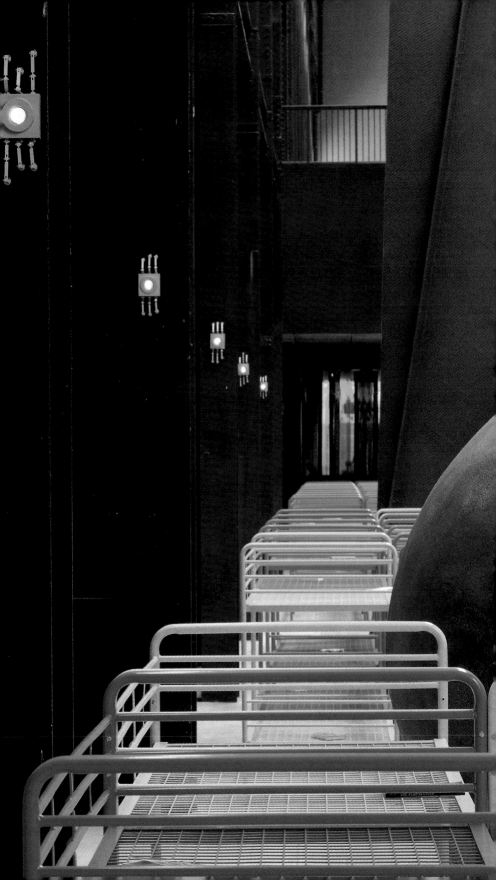

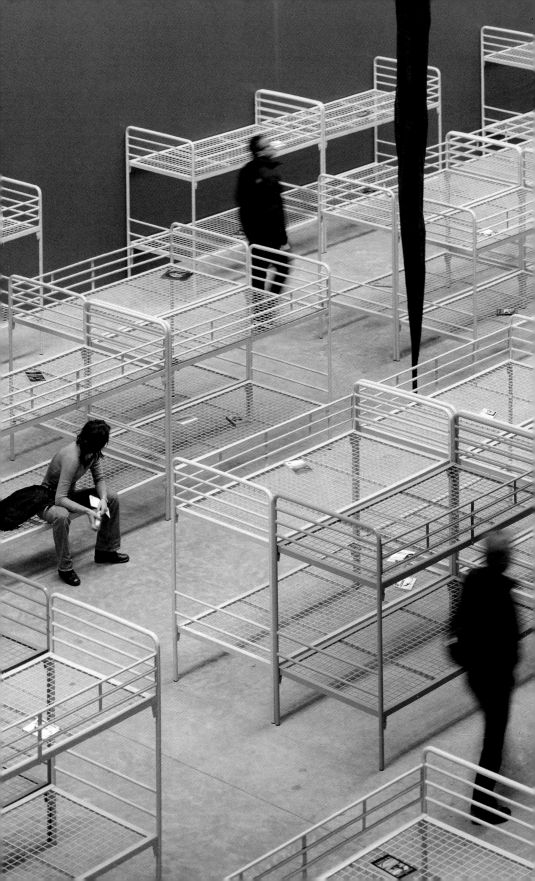

TH.2O58 155

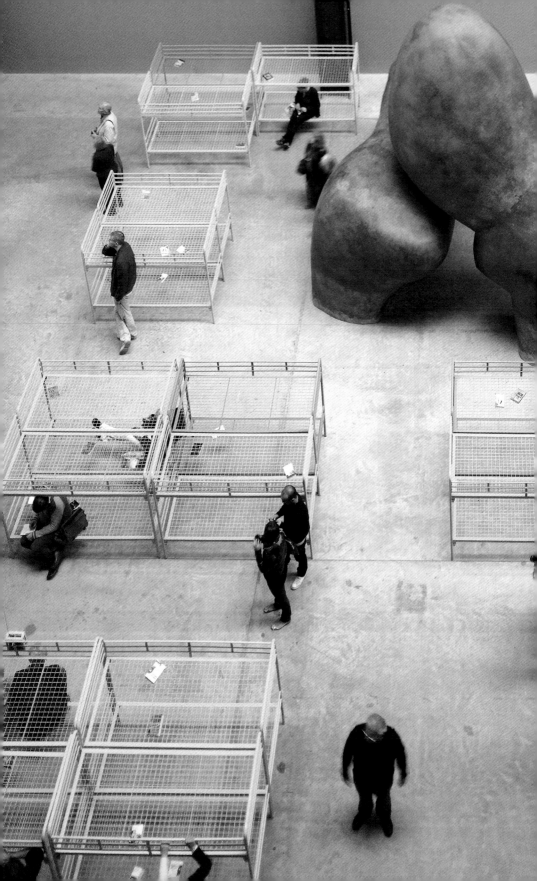

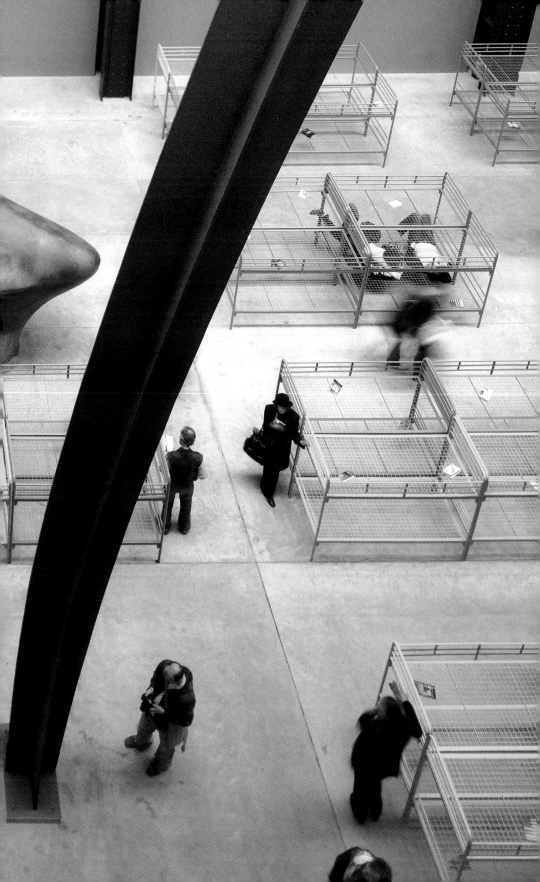

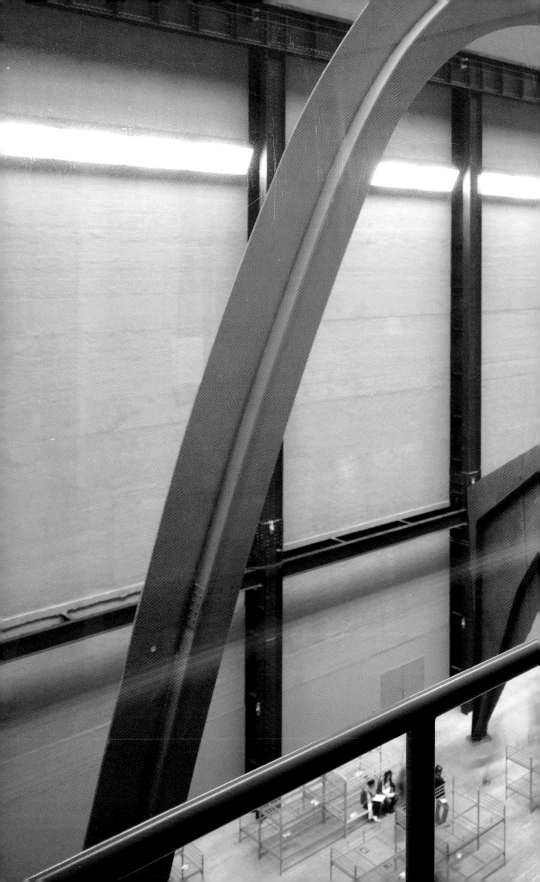

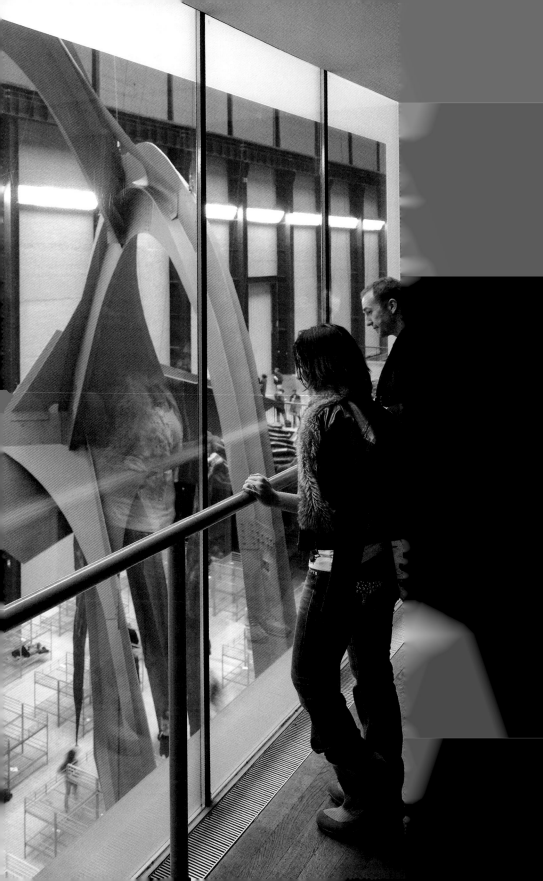

INTERVIEW WITH

WITH

DOMINIQUE GONZALEZ -FOERSTER BY JESSICA MORGAN

JM **Perhaps we can start at the very beginning of how you decided to approach the project?**

DGF Well, the very, very first approach — the prehistory — was just a very simple question: 'What is missing in this space?' So, then came a list: colour, water, plants and music. That was the first thing.

JM **Is that how you would normally approach a project?**

DGF It's how I approach an architectural situation. Not exhibitions in general. When I work where strong architecture is the context, where there is a dialogue with the building, this is usually how I start. When we're not talking about a white cube or even an outdoor context, when the presence of the space is very strong and tells a lot of things. So it's specific to a strong architectural context.

JM **When I first asked you if the Turbine Hall would be something you might be interested in thinking about you immediately said yes. Is that a reflection of a particular moment in your own work, or an interest in this scale in general?**

DGF No, I think it's a moment of the last few years where I've developed an interest in space beyond a domestic or exhibition scale. I like a situation that is closer to urban or landscape scale. Very early on I worked a lot on this analogy between the exhibition room and domestic space, and the possibilities of both. And then when I started to get more interested in urban space or open space, shared space or public space, I became much more attracted to spaces with this sheer possibility for walking around. This is easier to find outdoors, of course.

This is the situation I was looking for in Kassel for *Documenta* and why I was so excited to be invited to [the Skulptur Projekte] Münster, because for me this scale allows an approach that is beyond the object, where you are surrounded, where you necessarily have to move your body through space, where you are not contained.

JM **Your films in a sense always have that scale.**

DGF Yes, and they explore situations like this. They try to identify moments where there are parameters that generate a certain way of moving around.

JM **At Tate there are few barriers to entering the museum ...**

DGF It is an open museum. But there is still a difference in this space, which is half-public and somehow half-arranged. Where someone can enter without being completely sure they want to see an exhibition, or where there is still a doubt if it's an exhibition space. I think I would find it less exciting if it was already completely identified as a closed exhibition space. I think the quality of this space—to be something in-between—is also great.

So, yes, I feel the scale excites me. But I think the floods of people make it interesting. To me that is also the starting point.

INTERVIEW

Park – A Plan For Escape, DOMINIQUE GONZALEZ-FOERSTER, 2002
Roman de Münster, DOMINIQUE GONZALEZ-FOERSTER, 2007
Plages, DOMINIQUE GONZALEZ-FOERSTER, 2001

JM Let's return to the idea of what might be missing in the Turbine Hall, your first impressions.

DGF I came across this book on Hélio Oiticica in London and maybe I was just starting to consider what he would have done there. Maybe he would have made a giant *Penetrable*? And I think this is because of the scale of the space, how you go from the object or exhibition space to something that is beyond proportion. You have to think more like an architect. The scale is not domestic, or bodily … it's beyond that. So I think you need to work with the tools of the architect to think in this scale.

JM I like the idea of thinking about how to approach it through imagining what another artist might do.

DGF Well, for a long time I have had an Oiticica obsession. Maybe it grew stronger from spending time in Brazil. But also Lisette Lagnado suggested some correspondences between

our works in her essay for *Expodrome* [Musée d'art moderne de la ville de Paris, 2007], which I find exciting. There is a parallel, in fact, with what happened with Félix González-Torres; I always think that although we came from very different backgrounds, different genders, still there are some meeting points and with Oiticica it's the same: I think it's very different, totally different life, different bearing, different period of time. And still, in terms of how to think about art … the more I study his work, the more I am

164 TH.2058

Grand Nucleus, HÉLIO OITICICA, 1960–6

surprised how much I can relate, how close I feel, to his approach to art. So sometimes with Félix I also think 'What would Félix do?' now, in this situation. And this approach maybe has a bit to do with my interest in science fiction and anticipation. Imagining ...

JM **The interest in science fiction has been present in your work for a long time, the literary influence and the filmic. And so in a sense it's perhaps the obvious thing to bring to the space of the Turbine Hall. But I remember you were also talking about this idea of changing the history of the building—which carries with it a very strong sense of its past use as well.**

DGF Yes, because what happened to this space is in fact some kind of science fiction. A hundred years ago it's impossible to imagine that the people working there could conceive of what it would become. This shift says more than any other about the art inside the building. So I thought this was also a strong starting point. And then to imagine that there was one shift and what could be the second? And so I was imagining possible futures, something set fifty or a hundred years in the future.

JM **I like the idea of setting a stage: that through this you can address the present but also potentially the future, that it's both fiction and reality.**

DGF George Orwell's *1984* is a comment about 1948. And *The Martian Chronicles* by Ray Bradbury is about California in the 1950s. Science fiction always has this double aspect of being

an opportunity to comment on the present and the future, and it's exactly this tension that is interesting. It's only possible to imagine this fiction in the present moment, so therefore it's still dominated by the present.

One possibility that I imagined for Tate, or for the building, is that it could become a mall. If there is a crisis, or if the director changes, or the politics … But for me this notion is very difficult to approach in my work. So then I thought of another possibility: that at one point in London, because of climate change or another catastrophe, there might be a need for a giant shelter. And then I thought this shelter could house more than people, maybe, because it's a museum, that it could really have works in it—I think that the Oiticica concept came back. It's a kind of post-museum, beyond the sheer and great beauty of organised art. There is this immense pleasure of organising works in a system but beyond that there is a moment of relation to art that can be more organic or out of control.

JM But do you think that this idea of using a shelter space as a storage space is also to do with a flattening in a sense, a levelling, perhaps?

DGF Maybe. Of course it will also bring things closer to a library. An archive. The display is less obvious. And therefore things are grasped in a different way. The space could act as a giant vitrine or container for one idea or one work. This is where again the idea from Oiticica, of the nucleus blown-up as a model, emerged. And then I started to think of other works that would have this quality, other sculptures where

Fahrenheit 451, FRANÇOIS TRUFFAUT, 1966
Tube Shelter Perspective, HENRY MOORE, 1941

the body's more engaged ... not related to the white cube. To generate a space.

In fact at first I had three separate ideas. The first idea was a shelter, the *Soylent Green* shelter, just screens and beds. The second idea was the storage for giant sculptures. The third idea was the rain falling intermittently on people in the space and people acting like books, being books, like in *Fahrenheit 451* ... and then to a few friends, I said, 'I have these three ideas'. And one friend said, 'Why don't you bring them together?' (I think everybody had a preference for the shelter idea though.)

JM I think what speaks to people about the shelter idea is its relevance to London. So many people immediately think of Britain; sixty years on, still people remember these Henry Moore drawings of the Underground during the bombing.
DGF Do you know this really great photograph in a bombed library of people still reading books even though you can see there is no ceiling? This picture I have known for twenty years and it's always in my mind. Between culture and disaster ... It's also a very strong thing to explore.

INTERVIEW

Holland House Library, London,
after an air raid, 1940

JM **And then of course, after the fact—the recording of disaster through culture—the record is confused with reality.**

DGF Yes, of course London has this fictional potential. So then I thought, yes, it's true, it's a shelter—but I don't need to choose … the giant works can also be tried—the rain perhaps. And then it became a bit less *Soylent Green* oriented, because at the beginning it was more specific, like reconstructing a very heterogeneous space. Because it's giant artworks, it's film, it's books, it's beds, it's people. And it's a very powerful context. So the next phase is one of editing and to read more into it.

JM **Your work has never shied away from narrative, from using it as a source or a reference, that's very particular.**

DGF Well, because I see myself as a failed writer. My obsession, my dream is to be a writer. I cannot be, but with time I realised that my obsession with literature and maybe my place in literature is to transfer some aspect of literature into space, there is a possibility of a literature that is beyond print and paper, and probably this is where I hope to be.

I think it's this very big conflict, not only conflict but also productive zone between text and image, text and space. Because text is so dominating. When I worked on the rooms, I wanted to produce a new type of text that was not based on words and alphabet. Text creating space and space creating text. The whole is an amazing zone to explore.

JM **It's interesting that so much of your work has this sense of theatre, without theatre or script.**

DGF Without actors.

JM **The exception there would be the *Tapis de lecture* [*Reading Rug*] ...**
DGF Well, the *Tapis de lecture* really says very obviously 'This is my material'. When I work, basically, I read, I take notes, and I start from books most of the time.

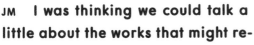
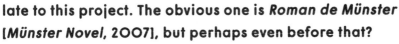

JM **I was thinking we could talk a little about the works that might relate to this project. The obvious one is *Roman de Münster* [*Münster Novel*, 2007], but perhaps even before that?**
DGF This week I was making a kind of biography in pictures for the MUSAC catalogue [*Nocturama**, Museo de Arte Contemporáneo de Castilla y León, 2008]. So I had to look at all the works. And the dormitory, the dormitory theme ... but the shelter as well, already popped up several times. Especially back in 1993, 1994. One exhibition called *Chambres Atomiques* at the Galerie Ars Futura [Zürich, 1994], was directly based on the Swiss atomic shelters. You know that each Swiss person has a bed in a shelter? Either they have a shelter in the house or, if they don't, they know where they should go. And I visited shelters for ten thousand people ... They are like really incredible fictions. Because they change the water, the

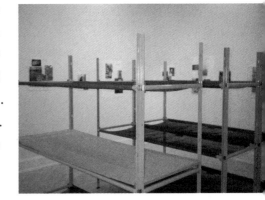

INTERVIEW

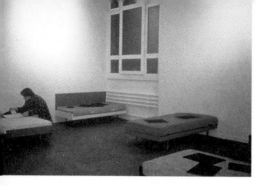

food every year—it's maintained perfectly. You have tonnes of food that is changed every year. Inside, you have a little prison, you have a mini-hospital.

And imagine, for ten thousand people, which means it's already a small city.

JM **And what was the project you made, that related to that?**

DGF It was on a more domestic scale. But still there were—I don't remember how many—of these bunk beds. And then I made a whole diary, a diary in pictures, a mix of pictures I took in these shelters and pictures from newspapers, some kind of archive. And I don't remember if it's two weeks', three weeks', one month's diary. This goes back—in fact, to the very first time I had to think about all that … As a child, we were not far from where they were building an atomic plant. And I was obsessed with the idea. I was asking my parents if we should have a shelter.

I think now it's different, but at the time the whole thing of Hiroshima, the atomic bomb. I remember nightmares where I would see the big light of the bomb … and as I already had some kind of obsession with space and rooms, I think that seeing the Swiss shelter was very interesting for me. So when there was my first exhibition in Switzerland there was suddenly this opportunity to

TH.2O58

Dortoir (Geneva), DOMINIQUE GONZALEZ-FOERSTER, 1993
TH Bed, DOMINIQUE GONZALEZ-FOERSTER, 2OO8

visit these shelters and I got very excited. I did another exhibition in another gallery in Geneva: I did this dormitory situation where there was a book on each bed, and also a mix of personal and kind of family pictures, mixed with things coming from the newspaper —each book was unique. The idea was that maybe this book was a way to figure out the person who occupied the bed.

And then there was a mini-dormitory—this was more for children at the Stedelijk Museum, in the Karel Appel room, which is great because it's very much like a nightmare (see p. 114). It's a completely painted room. It's also connected to another dream—a dream I had several times also as a child. In my dream I was an adult, in the future, and we were all on these bunk beds and couldn't move, but we had small screens—but at this time, you know, these computers didn't exist. But I think I was already reading lots of science fiction. And in this dream I was really scared by the idea that one couldn't move any more, and that we were somehow fixed on this bed. So I think it's not a new idea for Tate.

JM It's interesting that when one thinks of the *Chambres*, the series of rooms, it's very much about an individual home. Whereas as soon as you have multiple beds, the only situations you can think of with multiple beds are always somewhat negative.

DGF Yes, and what is interesting in relation to the museum is —I think it's in Walter Benjamin's text about Paris—where he draws attention to the difference between the nineteenth-century interior that works like a museum of memories and the

invention of these new, shared spaces, common spaces, that are the *passage*. We have a kind of *passage* situation here, not the commercial aspect, but I've always found this tension very interesting, especially now that I have left a bit the exploration of the domestic space. But I think much more that this shared space, or this space where people have to stay together—from a cinema to a square outside, to something much more difficult like a camp in any situation—is in fact more telling about the present than these mini-museum situations, which are hopes and not so relevant now. I mean, for me there is one interesting moment in the change of domestic space, which is how technology informs space. But then I'm still more interested by what can happen in the situation where people don't have …

JM Control over their universe?

DGF Yes, where they can make their mini-exhibition of the self. But it's about scale and technology I would say. A gallery space is close to a room and a space like this has … well, of course you can decide to divide it into two hundred rooms like *Species of Spaces* by Georges Perec.

But then, if you keep it simple, this shared space, where you have to negotiate the space with all the others inside, then there is a way to push one potential aspect, which could be the shelter. I was reading this Benjamin text again, and his use of quotes, I was also thinking of Godard and Borges, as three ways to approach this—Walter Benjamin for this use of quotes and literature and this hypertext. Godard in his *Histoire(s) du cinéma*, but also a connection between music, literature, film.

Histoire(s) du cinéma, JEAN-LUC GODARD, 1988–98

And then Borges was always turning literature into a gigantic library or archive, and that was something important for me. Those are really three ways to deal with culture. But they are also a way to build an exciting relation to the past and to culture. Like this permanent editing, reusing, quoting, but also giving a visibility not only to your own work or style, but to its situation or location in a kind of ensemble of things. So this is not so much related to the space, except that when you start to think of the museum as a kind of library, or having an archive capacity.

JM Is the project a commentary on the museum in that sense?
DGF I think in one part yes! And then what is interesting in the Turbine Hall is maybe it's a semi-urban situation, closer to a park. And parks are like a counter …

JM To the museum? But in terms of the merging of different media—literature, film, art ...
DGF I think this is one of the great traditions of the Pompidou, to keep all the mediums of art, the art approaches, together. So the possibility to have a kind of giant editing room for contemporary culture connected to a situation where one has to share the space in some way, which will be the impression that will be made, and made stronger by the beds, because the bed relates to a moment of the body that is more intimate. So I think this tension will be there. And then to be able to

connect directly the space with cinema, with culture, the visual arts together …

JM What about the idea, though, that in a sense you're also suggesting an end, or an endpoint?
DGF A catastrophe? An endpoint, I don't think so, perhaps it's something monstrous?

JM Monstrous?
DGF Monstrous editing. A monstrous editing of some iconic works that all have a relation to this space, which for me is very important. So in the case of Louise Bourgeois's work, there is this doubling, because there is a memory of the work here, but somehow it shouldn't be exactly the same. What is interesting in blowing up, enlarging, is that it entails an invention —a pure pop operation or approach—and it's an amazing way to make you look at something differently, and also to do some editing. When you blow up, it's like also in a film, when you have a blow up …

JM Then you simplify it, do you mean?
DGF Yes, or when you shoot something very close, or a close-up, then you really focus.

JM What's interesting, given you've done both, is the difference between scaling down and scaling up.
DGF In *Roman de Münster* what is essential is the relation to the whole city and to the exhibition in time since 1977. So in order to bring all this time and the works into one space, there

is only one possibility, it's to shrink it.

JM But the associations, I suppose, with the miniature, is one of control, whereas with the enlargement it's outside of control.

DGF It's out of control. Exactly. That's when you say it's a kind of catastrophe. We've come closer to *The War of the Worlds*.

And, I started to realise that what is amazing with all this urban sculpture, especially with Bourgeois, is that it's a very special case of people enjoying and liking to be scared. Because it's really a very unusual approach to public art, because there are very few works based on …

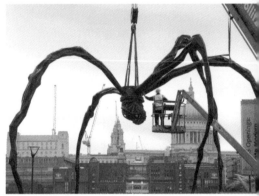

JM The dynamic of fear?

DGF Fear, yes, fear maybe is too much, but this repulsion, attraction. This is very unique in these works. And the closest reference we have to that is in science-fiction cinema. And these types of monsters invading the city only exist in cinema. And the Calder … I also realised that this animal aspect, like this giant, dinosaur, giant animals invading, the

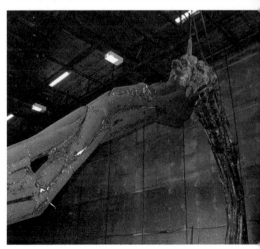

INTERVIEW

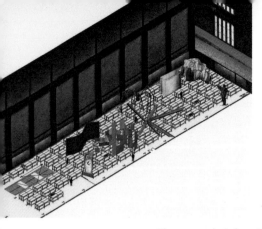

Calder flamingo, who have something beyond human scale, something monstrous. I think it's nice to explore this …

JM **That they encompass you in some way.**

DGF The model for that, for me, is really the Oiticica, something that has some kind of entropy. That goes against the idea of having one great idea for the space.

For this scale, for this context, for this format, I have the feeling that the only possible relation to art is one that relates to an archive. It has to deal with the eight exhibitions that have happened there before, but also the memory of the galleries next door.

JM **So we could go back to the beginning of your thinking about making these models and the idea about what happens when you blow something up.**

DGF The monster.

JM **How did you come to the idea?**

DGF Well, in fact, it's like quoting something using only your memory. In fact, part of the lecture by Enrique Vila-Matas [at the opening at MUSAC] was about the use of citations, quotes. And the way in which he has invented quotes attributed to Marguerite Duras … And that these quotes found their way back into the literary realm! But his way of quoting and transforming it a little bit is interesting for me. In the mid-1980s I was very interested in the Sherrie Levine appropriation process

and she was very much into Borges also. I think this whole appropriation thing is, of course, a typical postmodern experience like the relation to the past and the use of the collage and the mix. The king of that is Benjamin, of course—he's the one who puts quotes, reference really, into a different realm. I think on that level he's as important as Duchamp with the readymade. And then Borges comes a little after, and he goes beyond that quote, by giving the possibility to quote an entire book, for example, in *Pierre Menard, Author of the Quixote*. Or using references in such a way that they make the fiction real. And I think the one aspect that is interesting there, and it's also the way a quote works in a text, is that the sculptures will bring a reality effect.

JM **How would you differentiate, then, between the idea of the quote and the readymade? Or is that not important?**

DGF Well, I think the difference is taking it into a larger context. It's one thing to do this operation for one item, an isolated occurrence. And it's another thing to articulate all these together. And to go into something much more heterogeneous.

And that goes beyond this appropriation operation. Because then we enter this heterotopic field that again gives another sense of value to each of these operations. I mean each of these operations combined together is again another thing that is not as simple as the readymade. And then I think even after Borges with Godard it is even one step further, it's music, text, image and …

JM **Simultaneity, design, in itself.**

Untitled (Three Large Animals), BRUCE NAUMAN, 1989
Apple Core, CLAES OLDENBURG AND COOSJE VAN BRUGGEN, 1992

DGF So, in that sense, the amount of operations we will have going on in the Turbine Hall is very different to a readymade. One process has a kind of—not purity, but clarity. When this goes the opposite way by choosing the mess, it's the forest, as opposed to the singular.

JM **Maybe we can talk individually about the works chosen for replication?**

DGF Then there are several dimensions. One to bring up is this palimpsest that this space has developed from having

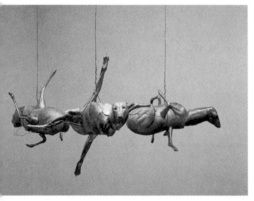

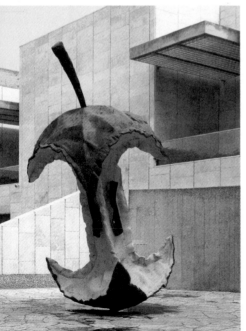

one exhibition after the other, which of course is invisible, but the traces remain. So to bring in the Louise Bourgeois, the Bruce Nauman, even the Oiticica, is really part of tracing into that space. But then there is also a tracing into a history of monumental sculpture, which is why we have Oldenburg and Moore and Calder, because their approaches to outdoor or large-scale sculptures —or, let's say, urban space-based work —is very significant. It is to put all these dimensions on the table: what has happened in that space and what has happened in the history of sculpture. This is why I very much like to go up to the present day with Cattelan, because I think it makes a longer timeline. And adds again …

TH.2058

JM **Another twist.**

DGF Again, this comes closer to literature, but then we have also this inter-textuality, these elements all bring their contexts with them—like the flamingo brings a bit of Chicago and the Henry Moore brings the countryside. We build a very complex landscape … And I think this landscape will appear again in the films, I really want that somehow the screen will also play on a much more simple level, just as a backdrop. Yes. And then the beds have the most in-between status. Because the operation there is a closer relationship to the readymade, but it also becomes like architecture.

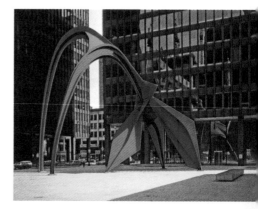

JM **And a suggestion of bodies, even if they're not there.**

DGF Yes, and then a lot of mini-stages, basically.

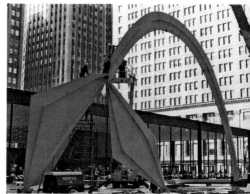

JM **So, back to the individual pieces, now that you've had success in getting permission, and we've been talking very specifically about how to make them. Has it made you rethink any of the works? This actual production process adds another layer...**

DGF Well, one important aspect of asking for permission is the way it made me realise how important each part is, and how desirable [laughs]. And how

INTERVIEW

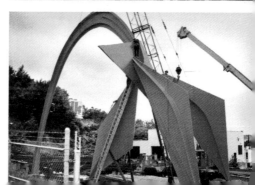

Flamingo, ALEXANDER CALDER, 1974

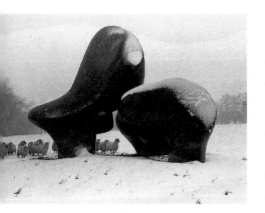

it's closer to a curatorial pleasure, which I've always enjoyed, and I've always thought that the line is very thin. But there, again, I found this immense pleasure that must be the one of the collector too, sometimes.

And then, when we went to Pinewood Studios, and we were lucky to visit the future Bond film set in a building that's about the same scale, I mean, the same surface area as the Turbine Hall—one thing that really made me think, and that had a bit of an influence on how the objects will be replicated, was the way they were working on preparing action, like pre-demolishing parts of the building, pre-burning. As if the architecture would incorporate the drama, the time, the action. And it was really good in making me think that maybe it's also good if we could have the replicas go through something—you know, since we are talking about something fictional, in fifty years' time, there could be some transformations like some ageing, or some virus or … I still have to think about that, because I find it very interesting that again we go back to a kind of quote from memory that is not really precise, and make a kind of corrupted quote.

But this was really a consequence of seeing this set, and the fact they had pre-scheduled the catastrophe.

JM Maybe we can talk about the film component?

DGF There was a first phase where I was thinking it should really mimic what happens in *Soylent Green* and have these

nostalgic views of a perfect Earth—like the film, to have this more ecological nostalgia. And then the second step was to go closer to the catastrophe, and work with film excerpts that might show these moments of flooding, disaster, but avoiding actors. So this would work more as a window on possible outsides, explaining perhaps why there is a shelter. And now the last list I made of possible films is more mirroring the shelter itself … Possibly other shelters, or trying to be more in relation with the sculptures, less a window and more a mirror. But it could be that it plays in between, you know, that some moments of film move towards the possible outside, and some moments go back to the inside.

JM **Last time we talked, you were talking about this arch-ive of images from *Chambres Atomiques*, is it from this material?**
DGF No, and it's all film-based. Like, for example, in *Soylent Green* you have this shelter scene, and in the great French film with Romy Schneider, in French it's called *La Mort en direct*, where she has this kind of sickness and she's followed by—it's from the early 1980s—a group; it's like one of the very first ideas of a reality show, but you also have these shelters … I'm still navigating between different levels of reference.

JM **That will close the space in much more, I had been think-ing of this landscape as extending the space through the screen … We've moved back and forth between having a standard film projection and an LED screen, but has that in-fluenced the material that you've thought about?**

DGF So far, not so much. Maybe the LED has brought it closer to the interior aspect. But also I'm really excited about the more abstract possibilities of the LED. And at some point want to establish a connection with the Calder being completely red, or to bring in an explosion of light in a different way … I think it just has more potential visually, it could act as much as a source of light.

And then the books, well, it was a good step to figure out that we might not need ten thousand or twenty thousand books … [laughs]. That one book per bed is enough. I like that.

JM **We were talking today about the poster, the marketing for this—and I was wondering to what extent you might feel comfortable with what the event is—what emergency has caused this transformation? Because it begins to raise questions about whether it's an ecological disaster, a political one …**

DGF Well, it's not a theme park, it's not a novel, it's not a film … And it's also not like I want people to think that they will go to see a film. I'd like to define a bit better what this new type of situation is, which is not a theatre play, but where still we use a lot of these tropes. And I'm a bit worried …

JM **People will of course ask: 'What happened?' Are you ecologically minded? Is that the issue? Is it a political commentary?**

DGF Of course I don't want to give only one answer. I think

this is important. And this comes back to whether it's in any way critical of the museum. And I think it's very important to make it readable, to keep it in that context. Even if some aspects are taken from other media.

JM That it's also a commentary on forms of display.

DGF Yes, for me now the layout of the exhibition at the MUSAC is not as meaningful as it was one or two or three years ago, this approach. I found it a bit abstract.

JM And what exactly was too abstract?

DGF The whole thing, I think, is too remote, too abstract in that sense—I mean, in the way an abstract painting is different from the room it's in. So metabolised and so ... digested, in a way. I don't know if 'abstract' is the right word, but it's the only one at present.

JM The very particular thing, I suppose, about the Turbine Hall projects—there are many particular things—but one is the atmosphere generated by the piece that then suffuses the space. Somehow it takes over the whole environment in a way that's unusual—you don't normally walk through an exhibition and experience an atmosphere in that way.

DGF What was not so easy for me from the beginning is that the empty space is already what I could have provided. It's

Solarium (Musac, Leon),
DOMINIQUE GONZALEZ-FOERSTER, 2007 / 2008

basically very close to some experiences I worked on. So then maybe the only possibility is to go the opposite way. And I liked the idea that—but this I think I already said—as opposed to an approach to art that is more organised like in the galleries, there will be something that is not habitual.

But it's also true that at one point, at the very beginning, I explored the possibility for there to be more plants, to go organic, because I felt this was something missing from the Turbine Hall. There is also something that is really taught by the space itself, which is latently present. Most of the time I've tried to use this instead of going against it.

JM **We have discussed the selection and thinking behind each of the replicas but perhaps now we can discuss further your ideas behind the film selection. It has changed over the process of the work's development and moved away from your original plan to include scenes not dissimilar to _Soylent Green_'s ending (featuring natural expanses). Perhaps you can expand on this shift?**

DGF In fact it's not exactly _Soylent Green_'s ending but one very important scene also known as 'Sol is going home' which I also used as a starting point for my contribution to _Il tempo del Postino_ curated by Philippe Parreno and Hans Ulrich Obrist at Manchester Opera House. In this scene an old man (Sol) goes to a euthanasia centre, and we can see him watching a 'last film' surrounded by the music (light classic) and colour (orange) he has selected for his chosen death. Taking place in 2022 in an extremely polluted and overpopulated context this film shows beautiful nature views from an unspoiled

planet Earth with no humans and no sign of human presence or construction: a field of flowers, a sunset beach, wild animals … This sequence is shown again with the end credits provoking a very disturbing melancholy. At one point, I thought about shooting some of these 'nature' moments all over the world (where it's still possible) but then I realised that it would somehow be too romantic and have a kind of light eco-green cliché aspect. So I decided to work on a 'Last Film' that would be made of remains of feature films, science-fiction films and experimental films, all related in different ways to the project.

JM Have these films featured or informed your work previously?

DGF Some of these films already appeared in another way and some are completely new. I asked film critic and director Luc Lagier to work with me on the project and he helped me discover fantastic films like *Toute la mémoire du monde*, a short film by Alain Resnais about the Bibliothèque nationale, which suddenly becomes a spaceship, a prison, a labyrinth, a fantastic space where books are circulating in a strangely human way, but also *The Last Wave* by Peter Weir and *Invasion of the Body Snatchers*. Some keywords like rain, archive, shelter, empty cities and desert oriented our research. Some films like *La Jetée* by Chris Marker but also *Alphaville* seem to have a matrix quality for this project, in an interesting way most of these films are from the 1960s and 1970s, which means that in 2058 they represent a hundred-year-old memory. Early science fiction has become a possible past rather than a dystopian future.

Toute la mémoire du monde, ALAIN RESNAIS, 1956
La Jetée, CHRIS MARKER, 1962

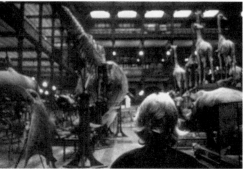

JM **The montage of the films creates a new film altogether, *The Last Film* as you have titled it. Can you talk a little about this idea of the remainder, the endpoint?**

DGF I'm very suspicious about any 'end of things' obsession or statement because I always have the feeling that it's very much informed/fuelled by our own ageing process. It's probably the 'last film' of one system but it's maybe the first film of another moment. In 1936, when Joseph Cornell, decides to edit in a new way the shots of an 1931 'B' film entitled *East of Borneo* he is inventing a completely new way to deal with cinema. When J.L. Borges introduces *Pierre Menard* and his Quixote, when Sherrie Levine shows *After Walker Evans* photographs, this quotation, appropriation, contamination process which runs through the twentieth-century production exemplified by some of Walter Benjamin's writings and continued by Enrique Vila-Matas, Chris Marker, Jean-Luc Godard, we are confronted by a reservoir of culture which is now as big, immense and extended as the world itself. Relating to this overwhelming archive is both an endpoint and a beginning. I imagine people entering his shelter and maybe first experiencing it as a depressing, gloomy situation but then by spending some time inside, some new possibilities might appear from this unusual

TH.2058

collage. Individual editing of this dense situation can provide a different passage between the experience of art and public shared space.

JM **The light effect in the Turbine Hall has also been developed to work in tandem with the film. As if the film perhaps carries some kind of message or effect. Can you say a little about how you imagine the light effect will function?**

DGF The set of forty lights (cycloraptors) conceived with Benoît Lalloz, a light designer with whom I have also conceived the *Cosmodrome, Panorama* and *Nocturama**, will be disseminated in the space like some kind of smart grid reacting to images from *The Last Film* and other elements from the shelter.

JM **The work has a title, *TH.2058*. For many it will recall the George Lucas title *Electronic Labyrinth: THX 1138 4EB* but I know that you have other ideas in mind including the strange coincidence of the significance of the years 1958 and 2058. Can you discuss this further?**

DGF Well, anticipating was a starting point, trying to imagine this space with another shift, from the early industrial cathedral to the successful museum and what it could become next … This title came first very naturally as a working title and then stayed. But what I discovered working on this projected shelter situation is that I was moving permanently between 2058 and 1958: around the time of *Hiroshima mon amour* and *Vertigo*, the invention of bossa nova, the Brussels *Atomium*, the creation of Europe as an institution, the construction of Brasília and Chandigarh, the first Sputnik in orbit. In the same way

1984 is 1948 for Orwell, 2058 is related to 1958 and *TH.2058* moves on a timeline in between.

We are dealing with how to cope with the archive, art and memory but through this exploration a different relationship to the future can appear. At the moment I'm obsessed with Chris Marker's sentence from the film *Sans Soleil*: '*Je vais passer ma vie à m'interroger sur la fonction du souvenir*', something like 'I will spend my life trying to understand the function of remembering'.

JM **The rainfall, unseen but perhaps heard in the audio component of *TH.2058* is the cause for this event, the shelter in the Turbine Hall. What made you think of this type of ecological change and what is the significance of the rainfall here—it is a feature of many of your works (either in the guise of rain, lakes and other watery expanses) but here the association is negative?**

DGF Not necessarily negative. In Tsai Ming Liang's films, water rushes into rooms; rain, rivers, stand for emotional changes and intense situations. Water is the starting point of organic life the way we know it, it's maybe the most primitive and important form of life on this planet. I can't think of something more emotional than water, rain, tears, waves, sea, lakes, but also clouds, icebergs, plastic bottles, dry seas, liquid deserts, limited or impossible showers, last drop, first drop.

JM **The book accompanying *TH.2058* is an extension of the fiction. The contributions by Catherine Dufour, Lisette Lagnado, Luc Lagier, Jeff Noon, Philippe Parreno and Enrique Vila-Matas all progress or develop the idea of the future presence of the Turbine Hall. Can you discuss the relation they have to the physical work?**

DGF In a way, as I have already experienced with both recent catalogues for *Expodrome* and *Nocturama**, I realised that working on the book is very crucial in defining the exhibition itself. In this case it takes the appearance of a science-fiction novel and I have asked several authors to use the same starting point—London, Turbine Hall 2058—and propose their own fiction. Their specific ways of relating, or not, to my own fiction helped me to make some important decisions, as a kind of script or scenario. The book also explores areas that are invisible in the exhibition and it is an experiment in itself. In *Toute la mémoire du monde* by Alain Resnais there is a fictional book entitled *Mars* with a mysterious woman on the cover circulating though the library-spaceship. I wish this book could appear for real in the *TH.2058* shelter. Whether this exhibition is more about science fiction or fantasy (*fantastique* is the word we use in French) is still an open question.

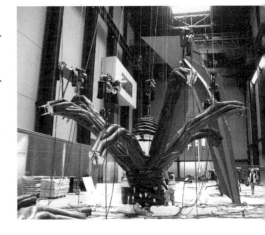

<div align="center">INTERVIEW 189</div>

CREDITS

BIOGRAPHIES

Dominique Gonzalez-Foerster is known for her highly evocative and atmospheric environments and films. Born in Strasbourg, France in 1965, Gonzalez-Foerster now lives in Paris and Rio de Janeiro. Her recent exhibitions include *Nocturama* at Museo de Arte Contemporaneo de Castilla y Leon (2008) and *Expodrome* at Musée d'Art Moderne de la Ville de Paris/ARC (2007).

Catherine Dufour is a writer. Author of *Blanche-Neige et les lance-missiles*, *L'ivresse des providers*, *Merlin l'ange chanteur* and *L'immortalité moins six minutes*, inspired by the Terry Pratchett's comedic fantasy book series *Discworld*, she has also written more serious books such as *Le goût de l'immortalité*, *Délires d'Orphée* and *L'accroissement mathématique du plaisir*.

Luc Lagier is a writer, film-maker and critic based in Paris. Author of *Les Mille yeux de Brian de Palma*, *Hiroshima mon amour*, and *Mythes et masques: les fantômes de John Carpenter*, he has also made documentaries about Jean-Luc Godard, Alain Resnais, Luis Buñuel and Brian De Palma.

Lisette Lagnado is Professor of Visual Art at the Santa Marcelina College in Brazil and has a doctorate in Philosophy from the University of Saõ Paolo. She was Chief Curator of the 27th Saõ Paolo Bienal in 2006, and is co-editor of the electronic journal *Tropico*, a member of the Consultative Council of the Saõ Paolo Museum of Modern Art, and widely published in international journals.

Jessica Morgan is Curator, Contemporary Art, at Tate Modern. She has organised group exhibitions such as *Common Wealth* (2003), *Time Zones* (2004), *Martin Kippenberger* (2006), and *The World as a Stage* (2007) and is curating the retrospective of the work of John Baldessari (2009) all for Tate Modern.

Jeff Noon was born in Manchester in 1957. He was trained in the visual arts, and was musically active in the punk scene before starting to write plays for the theatre. His first novel, *Vurt*, was published in 1993 and went on to win the Arthur C. Clarke Award. His other books include *Automated Alice*, *Needle in the Groove* and *Falling Out Of Cars*.

Philippe Parreno is an artist and film-maker based in Paris. Recent exhibitions of his work have been held at the Guggenheim Museum in New York, the Centre Pompidou in Paris, and the Museum of Modern Art in San Francisco. He has contributed to *Sound Unbound: Sampling Digital Music and Culture*.

Enrique Vila-Matas is one of Spain's most prestigious fiction writers. His books include *Historia abreviada de la literatura portátil*, *Suicidios ejemplares*, *El viaje vertical*, *Bartelby y companñía*, *El mal de Montano*, *Doctor Pasavento*, *Exploradores del abismo*, and *Dietario voluble*.